A to Z *of*
KNARESBOROUGH
HISTORY

A to Z *of*
KNARESBOROUGH HISTORY

ARNOLD KELLETT
Revised by PAUL CHRYSTAL

AMBERLEY

To our children, Ruth, Rachel, Tim,
and in memory of our beloved Annv

First published in 2004, revised 2011

Amberley Publishing
The Hill, Stroud
Gloucestershire, GL5 4EP

www.amberleybooks.com

British Library Cataloguing in Publication Data.
A catalogue record for this book is available from the British Library.

ISBN 978 1 84868 188 0

Typesetting and Origination by Amberley Publishing.
Printed in Great Britain.

Contents

Acknowledgements

Like all writers on local history, I am indebted to many who have gone before. Much of what follows has been gathered together from what is scattered throughout several books, especially those by E. Hargrove (1775), M. Calvert (1844), W. Grainge (1865), W. Wheater (1907), and the WEA study edited by Bernard Jennings (1990). It has also been culled from registers, almanacks, directories, pamphlets, newspapers, journals, letters, photographs, old postcards, and from helpful archives and libraries in general.

Above all, it has come from individuals with good memories and a love of Knaresborough. Many of the people it was a privilege to talk to have now passed into history themselves – Lord Philip Inman, Sir Arthur Collins, the Revd R. A. Talbot, George Smith, Mrs Mary Mann and Councillor George Clough, for example. Then there are many with valuable eye-witness accounts of old Knaresborough, such as Dennis Prest, Sid Bradley, Nancy Buckle, Walter Malthouse, Geoff Waite and fellow-members of the Knaresborough Historical Society, and also Knaresborough Town Council, the *Knaresborough Post* and the Tourist Information Centre.

In coping with all this elusive and fragmentary material, I have been greatly helped, as always, by my wife Pat, who has patiently toiled away to transform the complexity of my much-worked-over script into something orderly and legible. In this we have been glad to have the support of our friend Alan Hemsworth, particularly in computer work and proof-reading.

Colour photography and the photograph of Dr Arnold Kellett is copyright Paul Chrystal.

Finally, I would like to thank the many Knaresborough folk who have asked questions or drawn my attention to items of interest. I hope that in this book the questions are answered, the points of interest included, and that here

we have something which will help us all, young and old, to take a pride in Knaresborough's rich historical heritage.

Arnold Kellett

Preface to the Original Edition

Here is a little book crammed full of information, intended to provide the reader with something meaty and substantial, yet at the same time digestible and appetising.

My earlier books on the history of Knaresborough have usually presented the material in chronological order, forming a continuous narrative which tells, from beginning to end, the story of our remarkable town. This book takes a different approach. Individual topics are given in alphabetical order, constituting what I trust will make a useful compendium of Knaresborough's history for both residents and visitors.

The entries, which I have kept as compact as possible, are not simply snippets extracted from my earlier writing. In almost every case I have started from scratch and done further research, sometimes adding or correcting details discovered in recent months.

Although this book is for reference and browsing, I think it is important to show where these individual items fit into the general flow of the story of Knaresborough. So I have also worked out a chronological table, 'History at a Glance', and in the last pages you will be able to appreciate how the various bits and pieces of our history hang harmoniously together, and see them in context.

Some years ago, as one of my mayoral duties, I was showing a group of Americans round Knaresborough. I happened to refer to various key dates in our history – 1170, 1210, 1372, 1553, and so on. One of the Americans, open-mouthed, turned to his friends and said: 'Just *listen* to this guy, with these *dates*!' In the USA they can't, of course, go back very far, and we should be glad of the fact that in Knaresborough so much has happened in the course of the unfolding centuries. Dates can put people off, but I think they are a necessary evil – essential pegs on which to hang events worth remembering.

Let us be thankful, then, that we have such a wealth of dates and names in Knaresborough's history, many of them linked with national events. Few towns of our size can match us, or claim such an alphabet of curious and romantic items – even though I couldn't find anything beginning with an X! So dip in as you will, but keep glancing at those dates, and rejoice in the marvellous march of time, in the overmastering sweep of history in which we have been privileged to share.

Arnold Kellett
Knaresborough, 2004

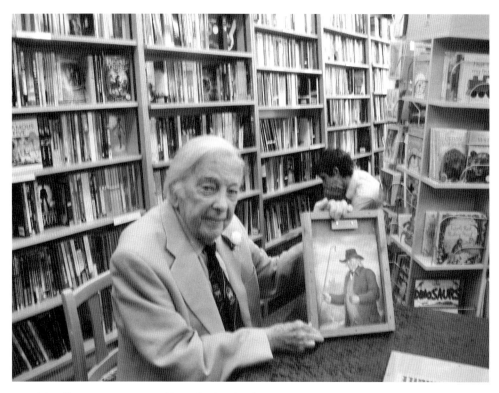

Arnold Kellett signing copies of his *Blind Jack of Knaresborough* at the lauch in 2008.

Preface to the Revised Edition

A to Z of Knaresborough History was an extremely popular, and useful, book when it was first published in 2004. Unfortunately, like many of Dr Kellett's numerous books, it has long been out of print, with the consequence that for some time there has not been an authoritative and comprehensive history of this wonderfully historical town available. Dr Kellett was in the process of revising the book just before his death in 2009, and I am privileged and honoured to have been able to complete that task and bring this revised edition to publication.

Paul Chrystal
Knaresborough, 2011

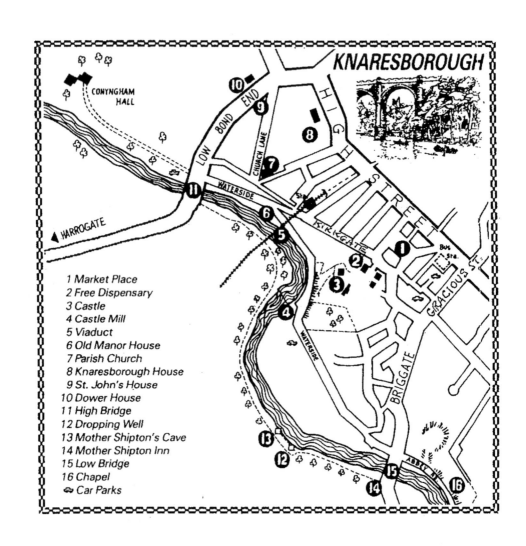

KNARESBOROUGH

1 Market Place
2 Free Dispensary
3 Castle
4 Castle Mill
5 Viaduct
6 Old Manor House
7 Parish Church
8 Knaresborough House
9 St. John's House
10 Dower House
11 High Bridge
12 Dropping Well
13 Mother Shipton's Cave
14 Mother Shipton Inn
15 Low Bridge
16 Chapel
🚗 Car Parks

A to Z of
Knaresborough History

AAGAARD, ROBERT (1932–2001)
Furniture maker with factories in the Cotswolds and Knaresborough and showrooms in Harrogate; the factory at Knaresborough makes high-quality period fireplaces and chimney pieces. He founded Cathedral Camps in 1980 and served as its chairman until his death; this is a youth movement recognised as part of the Duke of Edinburgh's Award. Robert Aagaard was also churchwarden at Knaresborough, and from 1995 a member of the General Synod of the Church of England until 2000.

ABBEY ROAD
(See Knaresborough Priory)

ACTS OF PARLIAMENT
Three of the most important affecting Knaresborough were: 1764, when Leonard Atkinson and John Lomas were officially authorised to pump water from the Nidd; 1823, when Knaresborough was first administered by a body of Improvement Commissioners, forerunners of the Town Council; 1885, when Knaresborough was disfranchised, losing its right (because it had far fewer than the required 15,000 inhabitants) to continue to elect its own MP.

ALMANACK
First published in 1857, *The Knaresborough Household Almanack and General Advertiser* was a popular handbook for the town, appearing every year in

time for Christmas until the late 1920s. It gave details of local government, churches, schools, societies, sport, a summary of recent events, and reflected Knaresborough's trade in a variety of adverts for shops and businesses.

ALMSGIVING

This is referred to in wills and various other documents throughout Knaresborough's history. The parish church possesses an ornate poor-box, bearing the date 1600 and the names of William Prist and John Wooler, churchwardens. (See Almshouses, Charities, Royal Maundy)

ALMSHOUSES

A plaque at the top of Kirkgate marks the site of almshouses 'for six poor folk' mentioned in a survey of 1611. Others near High Bridge, seen in early photographs, were demolished when the Claro Laundry was built in 1902.

ANCIENT BRITONS

The earliest known inhabitants of the Knaresborough area, part of the Celtic settlement around 500 BC. The fierce tribe of the Brigantes had their headquarters at Iseur, a few miles to the north-east at Aldborough, near Boroughbridge. When the Britons were finally defeated by the Romans in AD 74, this was replaced by the walled city of Isurium Brigantum, covering 60 acres, the most northerly of the Romano-British towns. One legacy of the Ancient Britons can be seen in the name of our river. (See Nidd)

ANGLES

Following the withdrawal of the Romans in the fifth century, there was an invasion and settlement by Germanic tribes, mainly Saxons in the south and west of England, and Angles in the north. It was the Angles who gave their name to the whole country (England was originally *Engla-land*, the land of the Angles). They also named many of our towns and villages, those ending with their word *burg* (fortified settlement) becoming 'borough'. 'Knaresborough' has been said to be derived from the name of some unknown Anglian chieftain (i.e. *Cenheard's burg*), but is more likely to have originally been 'Knarresburg', meaning the fortress on the rock.

ARAM, EUGENE

Born at Ramsgill in Nidderdale in 1704, Aram moved to Knaresborough in 1734 and started a school at the top of High Street, in White Horse Yard (now Park Square). A self-educated scholar and linguist, he became involved in a fraudulent scheme with a flax-dresser, Richard Houseman, and a young shoemaker, Daniel Clark. On 7 February 1744, Clark disappeared, and it was assumed he had absconded with the defrauded valuables. Soon afterwards, Aram paid off his debts and left Knaresborough. In August 1758, a skeleton was discovered, buried on Thistle Hill. Houseman, accused of Clark's murder, denied that the bones were Clark's and eventually confessed that he was buried in St Robert's Cave, where he had seen Aram strike Clark down. Traced to King's Lynn, the schoolmaster was arrested and imprisoned in York Castle. In spite of his learned defence speech he was found guilty at York Assizes and, on 6 August 1759, condemned to be hanged in York, and later hung on the gibbet in Knaresborough, just above the Mother Shipton Inn. Two writers made Eugene Aram well known to Victorians – Thomas Hood, in *The Dream of Eugene Aram*, which vividly describes his guilty conscience, and Bulwer Lytton in a fanciful novel, *Eugene Aram*, which attempts to exonerate him.

ASPIN PONDS

Originally fish-ponds belonging to Knaresborough Priory. Two of these can be traced – one near the Priory on Abbey Road, the other on Crag Top, near Knaresborough Cricket Ground. The name, probably originally *asper* (Latin for rough), has been borrowed by the extensive Aspin housing estate. (See Knaresborough Priory)

ATKINSON, W. A.

A local historian, author of *Goldsborough* (1922), *Knaresborough and its Manor Houses* (1924) and *A Guide to Knaresborough Castle* (1926).

BANKS

One of the earliest of Knaresborough's banks was the Knaresborough & Claro Bank, established in 1817, with deposits which had amounted to £88,299 by 1836. The present building in High Street dates from 1858, and is now the NatWest Bank. The clock, presented by Knaresborough Rotary, was installed in 2000 to mark the millennium.

In Victorian times, a Penny Savings Bank had been established in the Castle Girls School, followed by the Yorkshire Penny Bank in the Market Place, but

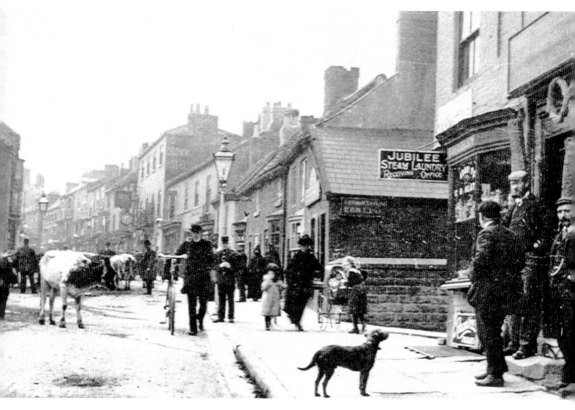

The High Street in the early 1900s, with cattle being driven to the fortnightly livestock market.

since 1959 the Yorkshire Bank has been in place. In 1881, the Bradford Old Bank built an imposing red-brick building in High Street which is now Barclays Bank.

BARBICAN GATE
The twin towers at the main entrance to Knaresborough Castle, originally with a drawbridge and portcullis. This gate features on the seventeenth-century seal which has become Knaresborough's emblem.

BARBER, S. C.
Archaeologist who worked on Knaresborough Castle, publishing *The Excavations* (1925–26) and arranging an exhibition of artefacts in Castle Boys' School, which in August 1926 was visited by Princess Mary and Viscount Lascelles.

BATTLES

In its long history, Knaresborough contributed to a number of battles, including Bannockburn (1314), when many Knaresborough men were killed, including William de Vaux, Constable of the Castle, and in the Wars of the Roses at Towton (1461), when Knaresborough men, including Sir William de Plumpton, were among the estimated 20,000–38,000 killed. Lives were also lost in the siege of Knaresborough Castle (1644), and also in 1914–18 and 1939–45. (See Castle, Civil War, Siege of Knaresborough Castle, First World War, Second World War)

BEBRA

(See Town Twinning)

BEBRA GARDENS

(See Moat Gardens)

BECKET, THOMAS

According to the Chronicle of John de Brompton, the four knights who murdered the Archbishop Thomas Becket in Canterbury Cathedral (29 December 1170) fled north and took refuge in Knaresborough Castle. This was because their leader, Hugh de Morville, was Constable of the Castle. The chronicler says that the dogs of the castle refused to eat the scraps which these four assassins threw from their table.

BED RACE

Started by the Knaresborough Round Table in 1966, this charity event opens with the judging of the decorated beds, which then proceed around the town before being stripped down to race, finally crossing the Nidd to finish in the grounds of Conyngham Hall. Since 2002, the Bed Race has been organised by the Knaresborough Lions. The year 2011 saw the 46th annual Great Knaresborough Bed Race, with the theme 'British History'. The Bed Race is now world famous and is characterised by its colour and pageantry, the courage and endurance of its teams, and the glorious eccentricity of its entrants. For many years, TV coverage has boosted the event's popularity, including when the BBC's *Songs of Praise* programme chose the Bed Race 2010 as the theme of its broadcast on 11 July. In past years, *Blue Peter*, Channel 4, Nippon TV, and

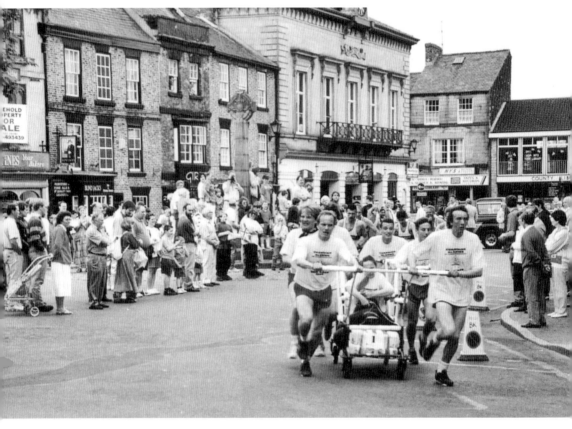

A typical scene from the town's world famous Bed Race, with contestants passing through the Market Place.

many others have also featured the race, ensuring global coverage. The race features ninety teams of six runners and one passenger and it is estimated that in recent years around £80,000 has been raised for various charities.

BEECHILL, MANOR OF
Surrounding the parish church, the small manor of Beechill was a prebend of York Minster from 1230, bringing in tithes to the prebendary, who held two ecclesiastical courts a year here. (See Manor Cottage, Old Manor House)

BELL, FENTON
Well-known Knaresborough draper and outfitter whose business was established in Knaresborough in about 1903, later at the corner of Finkle Street

and High Street, where it was destroyed by fire in 1941. Carried on by his son, Howard Bell, an old pupil of King James's Grammar School, the shop was, for many years, the main supplier of the school uniform.

BELLS

A peal of eight bells was installed in the parish church of St John in 1774 by the vicar, the Revd Thomas Collins. The cost (£462 3s) was reduced by making use of four melted-down old bells, said to have come from Knaresborough Priory. The bells were re-tuned in 1925, retaining their original inscriptions. For example:

> Such wondrous power to music's given,
> It elevates the soul to heaven.

The ringing of a bell from the church tower goes back to Norman times, when the Curfew Bell (q.v.) was rung. The Pancake Bell was rung on Shrove Tuesday, and a bell was rung to guide people to Knaresborough on the eve of Market Day, which is why bell-ringing practice is traditionally on Tuesday night. Another old tradition was to toll the bell to announce a death – thirty strokes for a man, twenty for a woman and ten for a child.

BELMONT OAK

Situated on what is now the golf course, near Belmont Junction, this was an ancient and massive oak tree, almost as famous as the one at Cowthorpe. An early print shows it to have been hollow, with an entrance, and a kind of dovecote built into its branches. It was still standing in the early 1900s.

BIRNAND HALL

In Tudor times, this house in York Place was the home of William Birnand, Recorder of York. It was rebuilt in about 1780 by William Manby, and is now the Conservative Club. Nearby is a small brass cross in the pavement, marking the site of a stone cross set up at the entrance to the town, where early magistrates are said to have administered justice.

BISHOP OF KNARESBOROUGH

The title of a bishop who serves as an assistant to the Bishop of Ripon and Leeds, though he has no special responsibility for Knaresborough. This post

was only created in 1905, but the term 'suffragan bishop', applied to the holder, is ancient, and originated in such bishops being called on to vote at synods.

BLACK DEATH

Bubonic plague spread by flea-ridden black rats wiped out a third of the population of England, and struck this part of Yorkshire in 1349. The Black Death carried off about half the population of Knaresborough, including the vicar, Robert de Neville.

BLACK DOUGLAS

(See Scottish Raids)

BLACKSMITHS

For most of Knaresborough's history the importance of horses, and the numerous livery stables, meant that blacksmiths and related trades were an essential part of the community. The *Directory* of 1820, for example, lists seven blacksmiths and farriers in the town. The last-known old forge and blacksmith's was discovered during renovations of 8 and 10 Market Place in 1989, when we were able to examine and photograph the forge in the basement, with its huge bellows and massive counterweight. This building had also been an ironmonger's – Robert Gott's in the 1800s and J. W. Mason's in the 1900s. In recent years, there was Castle Forge in Cheapside, specialising in wrought iron.

BLENKHORN, CHARLES

Publican of the World's End, near High Bridge, where, in 1900, he opened the New Century Dining Rooms and hired out pleasure boats. Charles Blenkhorn and his sister also served as Knaresborough post-masters. (See Boating, Postal Services)

BLIND JACK

Nickname of John Metcalf, who was born in 1717 in a cottage (demolished in about 1768) near the parish church and was a true jack of all trades. He went to school aged four, but at the age of six he was afflicted by smallpox, which left him completely blind. An intelligent lad with prodigious determination and energy, he led an active life tree-climbing, swimming, hunting and gambling.

At the age of fifteen, he was appointed fiddler at the Queen's Head in High Harrogate. Later, he earned money as a guide (especially at night-time), eloped with Dolly Benson, daughter of the landlord of the Royal Oak (later the Granby), and in 1745 marched as a musician to Scotland, leading Captain Thornton's 'Yorkshire Blues' (q.v.) to fight Bonnie Prince Charlie's rebels.

Blind Jack is best known for his work as a pioneer of road-building. His extensive travels and the stage-coach he ran between York and Knaresborough had acquainted him with the appalling state of English roads. Soon after a new Turnpike Act in 1752, he obtained a contract for building (with his gang of workmen) a 3-mile stretch of road between Ferrensby and Minskip. Then he built part of the road from Knaresborough to Harrogate, including a bridge over the Starbeck, and went on to complete around 180 miles of road in Yorkshire, Lancashire and Derbyshire. The specially constructed via-meter he used to measure his roads can be seen in our Courthouse Museum.

Following Dolly's death in 1778, he went to live with a married daughter in Spofforth. Here, after many active years in business and as a violin-player, he died in 1810, leaving behind four children, twenty grandchildren and ninety great and great-great grandchildren. A tombstone in Spofforth churchyard pays tribute to the remarkable achievements of 'Blind Jack of Knaresborough', and he was commemorated with a sealed bronze statue in Knaresborough Market Place by Barbara Asquith in 2009.

BOATING

The section of the River Nidd running through the town, with its delightfully varied views, has long been popular for recreation in boats, and, more recently, canoes and punts. The first known provider of boats was William Bluet, who died in 1850. He was followed by Richard Sturdy of Richmond House, whose landing stage and boathouse were just below the castle. The work, including boatbuilding, was continued during the 1900s by his son, Frank, and a veteran boatman, George Smith. The last boat was built here in about 1927. Sturdy's was originally licensed for 140 boats. A second boatman, Charles Blenkhom, adjacent to High Bridge, started with ninety boats. Sturdy's was taken over after the war by Billy Henry, who sold it to the Council in 1965. (See Blenkhorn, Charles, Penny Ferry, Punting, Water Carnival)

BOND END

The name for the once-distinct community at the bottom of High Street originates from the fact that the boundary of the outer area in which serfs or

bondsmen once lived was situated here. Above and beyond Bond End was the Free Burg of Knaresborough itself, whose inhabitants were, in 1310, granted the various freedoms enjoyed by burgesses. (See Burgage Houses, Charter.) In 2011, buildings at the junction with High Street were demolished and replaced with new housing, which fits in well with the surrounding architecture.

BOROUGH BAILIFF
The principal officer keeping law and order in the town, from medieval times until the nineteenth century. He was a kind of Justice of the Peace, presiding over the Borough Court. Some Borough Bailiffs were wealthy and influential, including Peter Benson, who, by 1611, had sixteen burgage houses (with their voting rights), and in 1616 donated a house for the new grammar school (see King James's School). One of Peter Benson's houses later became appropriately known as the Borough Bailiff, which has served as an inn since about 1720, for many years called the Commercial Hotel.

BOROUGH COURTHOUSE
(See Sessions House)

BOXING
In the 1930s, usually on Monday evenings, popular bouts were held in the boxing-ring behind the Elephant & Castle, High Street. Well-known throughout the North of England was the Knaresborough boxer, Leslie 'Dot' Fowler, who later had a barber's shop at the bottom of High Street.

BRIAN DE LISLE
The right-hand man of King John in Knaresborough, appointed as Constable of the Castle in 1205, who later became the King's Seneschal and, in the last year of his life (1233–34), was appointed High Sheriff of Yorkshire. Brian oversaw the development of the castle, the production and export of many thousands of crossbow bolts, the first known Royal Maundy and the King's visit to St Robert. His stipend was £48 13s 4d a year – sufficient to ensure his loyalty. (See Castle, King John, Royal Maundy)

BRIDGES
(See Grimbald Bridge, High Bridge, Low Bridge, Viaduct)

BRITISH LEGION
Founded nationally in 1923, the Knaresborough branch dates from 1927, since which time it has consistently supported servicemen and their families, organised the annual Poppy Day collections and, in particular, overseen the Armistice Day and Remembrance Sunday processions and services. (See First World War, Second World War, War Memorial)

BUCKLE, NANCY
Thomas Hill, of House in the Rock fame, is the great-great-great-great grandfather of Nancy Buckle, who was Knaresborough's first (and only so far) lady Town Crier. As a teenager, Nancy auditioned for and was accepted into the Bluebell Showgirls; however, the aunt with whom she lived refused to sign her papers to allow her to travel to Las Vegas with them. (See House in the Rock, Town Crier)

BURGAGE HOUSES
These were held by the Free Burgesses of Knaresborough, who paid a nominal rent of one penny, known as 'the borough penny', for a house with a garden or garth. By 1305, there were eighty-six burgage houses in Knaresborough, each tenant later having the right to vote in parliamentary elections. (See Charter)

BUTTER LANE
The ginnel from the Market Place to High Street, so called because it was traditionally where folk from the farms sold their milk, eggs and butter.

BYARD'S LODGE
House at High Bond End and home of linen manufacturer John Walton (see Walton & Co.). From 1861, it was the home of Captain Henry Balguy of the 5th West Yorks Militia, who, from 1858, used the old workhouse as their barracks. (Later, the West Yorks Rifle Volunteers and Yorkshire Hussars were also based in the town.)

CALLAHAN, BILL (BORN 3 JUNE 1966)

American singer-songwriter and guitarist also known as Smog, who lived in Knaresborough for eight years in the 1960s and 1970s. The music reviewer in the *Independent* in 1997 said:

> There's a song he wrote called *I Break Horses* on *Kicking a Couple Around* which can reduce strong men and women – people who work on oil rigs, people who understand the Inland Revenue's new Self- Assessment system – to heaps of quivering gelatine.

CALCUTT

The name of this settlement, rather than a village, derived, according to Wheater, from 'road to the wood'. By Victorian times, it was big enough to merit the building of Thistle Hill Chapel (q.v.), described as 'for the convenience of the inhabitants of Calcutt Houses', the oldest part of Calcutt. This was a convenient place to live for workers at the old quarry, lime kilns and brick works on Thistle Hill. In the Second World War, the field behind the Union Inn was requisitioned for training and as a rifle range. The Union Inn dates from the early 1800s, and the name refers to the Union of Great Britain and Ireland in 1801 (see Cricket). Calcutt has nothing to do with Calcutta; this is the anglicised name for Kolkata, which has its roots in Kalikata, the name of one of the three villages in the area before the arrival of the British.

CALVERT, MICHAEL

A Knaresborough chemist who worked to promote the reopened spa at Starbeck, serving as secretary and treasurer of the Spa Trust from 1822 to 1849. In 1844, he published a short *History of Knaresborough*. (See Knaresborough Spa)

CAROL SERVICE

Traditional singing of carols led by the Knaresborough Silver Band in the Market Place, including the switching on of the Christmas lights by the mayor. In 1979, the mayor, Arnold Kellett, started the custom of directing the Carol Service from the balcony of the Old Town Hall, introducing Santa Claus, and encouraging children to bring lanterns of candles in jam-jars. In recent years, the Carol Service has served as a prelude to Edwardian Sunday.

CASTLE

Knaresborough Castle has its origins in the fortified settlement or *burg*, which was referred to when the Angles named this place Knarresburg. Strategically placed on rocky ground towering over the Nidd some 120 feet below, the fort was developed as a castle by the Normans, traditionally under Serlo de Burgh, who had fought with William at Hastings. In 1130, Henry I authorised Serlo's nephew, Eustace Fitz-John, to develop the castle, and soon this was a base for hunting wild boar and deer. (See Forest of Knaresborough, Becket, Thomas, Pageant, Siege of Knaresborough Castle)

In 1205, King John appointed Brian de Lisle (q.v.) to extend and strengthen the castle until it became one of the most important military and financial centres in the north, a base from which he could control rebellious barons. He authorised the digging-out of a huge dry moat, started in 1204, and the production of quarrels or crossbow bolts in the castle forges. (See Quarrels)

King John's castle was completely rebuilt for Piers Gaveston by Edward II between 1307 and 1312, so that it was now a fine residence as well as a stronghold, with a dozen towers and a great keep – the total cost was the impressive sum of £2,174. (See Gaveston, Piers, King John)

Following the defeat at Bannockburn, Edward II had to contend with rebellions in England. On 5 October 1317, a rebel knight, John de Lilleburn, took Knaresborough Castle and held it until 29 January 1318, when it was recaptured by the King's forces. Later that year, it proved too strong for the Scots to take (see Scottish raids). From 1328, the castle became the occasional residence of Edward III and Queen Philippa, and also their sons, the Black Prince and John of Gaunt. In 1372, Edward granted the castle and Honour of Knaresborough to John of Gaunt, Duke of Lancaster, since which time it has been part of the Duchy and, therefore, belongs to the Queen (see John of Gaunt, Queen Philippa, Richard II). In Tudor times, it was greatly admired by John Leland, who, in 1540, noted that 'The Castel standeth magnificently and strongley on a Rok'.

The ruins we see today are of Edward II's castle, reduced to this state by Oliver Cromwell's Parliamentarians, not as a result of warfare, but by slighting – the systematic dismantling of Royalist castles – which was carried out here in 1648. Knaresborough Castle had been taken by the Parliamentarians in December 1644 (see Siege of Knaresborough Castle). Little remains to remind us of its original splendour, except the Barbican Gate (q.v.), the keep, and the one thing Cromwell could not destroy, the famous panoramic view of the Nidd Gorge. (See Dungeon)

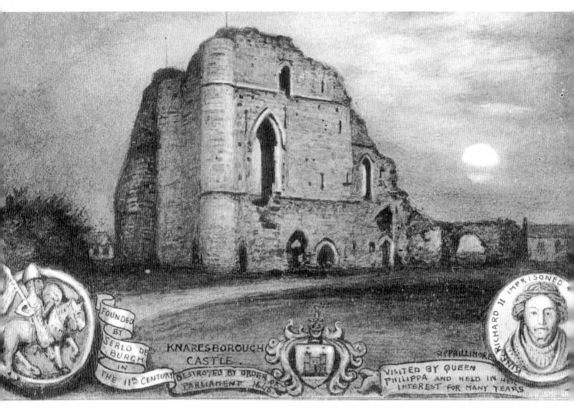

Knaresborough Castle with important events in the castle's history.

CASTLE MILL

Standing on the banks of the Nidd just below the castle, this building originated as a paper-mill, built in 1770 on the edge of the weir, making use of the water-wheel which had pumped water up into the town since 1764 (see Acts of Parliament, Water Supply). It was rebuilt as a cotton mill in 1791, adapted for the spinning of flax and weaving of linen in 1811, and by 1847 had been taken over by the biggest employers in Knaresborough, the firm of John Walton, which had been established in 1785. Walton's produced linen of the finest quality, and had been appointed by Queen Victoria in 1838 as 'suppliers of all the royal palaces'. Castle Mill flourished under Walton's, who had increased their workforce to 423 by 1851, the year they won the Prince Albert Medal at the Great Exhibition (see Seamless Shirt). The last manufacture of linen at Castle Mill was in 1972, and the firm, as linen merchants, left Knaresborough in 1984, when the building was sold by Harrogate Borough Council for residential development, though some of the external features of the mill were retained. (See Linen Industry, Walton & Co., Wilson, Harriet)

CASTLE SCHOOL (BOYS)

Built in the Castle Yard in 1814, this was established mainly through the efforts of the vicar, the Revd Andrew Cheap, officially as a school of the 'National Society for the Education of the Poor in the Principles of the Established Church'. Though the Duke of Devonshire contributed £500, most of the cost of building the school was met by public subscription. By 1833, there were 170 boys being educated at this school – all under the strictest discipline, with regular caning, a regime which continued into the twentieth century. The headmaster at Castle Boys was traditionally known as 'Gaffer'. Two of the more recent were 'Gaffer' J. H. Smith, who started just before the First World War, followed in 1934 by 'Gaffer' Edward Wright, by which time it had become a Junior School. The headmaster from 1966 was Harry Colley. In 1971, the school moved to the vacated premises of Knaresborough County Secondary School, Stockwell Road, to become part of Castle School (mixed).

CASTLE SCHOOL (GIRLS)

While boys were being educated in their purpose-built school from 1814, girls were being taught in the porch of the parish church and in a room adjoining the vicarage. In 1837, however, the equivalent of the boys' school was opened, just opposite, at the other side of Castle Yard. There was the same emphasis on providing for children from poorer families, as is indicated by charitable awards such as the Stevens Bibles and the Marshall Suits (q.v.).

By 1844, the school had eighty girls who were being 'instructed in reading, writing, accounts, knitting and needlework'. In addition, eighty infants were taught in the same building, and in 1875 a second storey was added, making it the biggest school building in the town. As in the case of Castle Boys' School, continuity was provided by long-serving head teachers: from the 1890s until after the First World War there was Miss Smith, with Miss Dorcas Southwell as headmistress of the Infants. Then came Misses Fanny Quintrell and Florence Mellish, with Miss D. R. Arnold, daughter of the organist and choirmaster at St John's, as head of the Infants. More recent heads were Mrs Dorothy Wignall and Miss Dorothy Williams, later Mrs Gregory, with Miss E. A. Willis as deputy.

CASTLE YARD RIOTS

The name given to a public protest in Knaresborough in 1865 against Dr John Simpson, who lived next to Castle Girls' School and had fenced off the popular right of way down past the castle to the river. Led by a tailor called William

Johnson, Knaresborough men had made many attempts to break open the locked gates, and Simpson, a JP, had struck Johnson with a stick. Eleven men, including Johnson, were arrested and imprisoned for three months. On their release the men were hailed as martyrs and each presented with an inscribed silver tankard by the grateful Knaresborough public.

CATHOLICS

Before the Protestant Reformation of the sixteenth century, all Christians in Knaresborough were, of course, Roman Catholic, and the parish church, then known as St Mary's, had close links with Knaresborough Priory (see Pilgrimage of Grace). The last attempt to withstand the reforms under Queen Elizabeth came in 1569, with the Rising of the North, when Catholics broke into Knaresborough parish church, destroyed the Protestant prayer books, and for one last time here heard Mass in Latin. A Catholic presence continued in the area, in spite of strong opposition, and it was this which favoured the conversion and enlistment of Guy Fawkes (q.v.) in nearby Scotton.

It was not until 1791 that Catholics were allowed to worship in their own licensed chapels. In 1797, a priest from the Catholic mission in Follifoot moved to Knaresborough, converting an old mill in Union Street, Briggate, into a Roman Catholic chapel. He was Father Anselm Appleton, a Benedictine, who, in 1802, left Knaresborough to become the first Prior of Ampleforth Abbey. The Catholics of Knaresborough have always had a strong connection with Ampleforth, and the priest is traditionally a Benedictine. St Mary's Catholic church opened in Bond End in 1831, and soon there were 100 children being taught on the premises and, by 1851, there was a total of 250 practising Catholics in Knaresborough. (See St Mary's Church)

CATTLE MARKET

All the early references to Knaresborough's weekly cattle market show that it was held in the High Street, and that the obstruction, muck and stench were a constant nuisance. In Victorian times, the Improvement Commissioners ordered the washing-down of the filthy street after each market day, but it was not until 1907 that a permanent site for the cattle market was established on land between High Street and Stockwell Road. In 1909, the firm of Thornton and Linley, auctioneers and agents, started their long association with Knaresborough's livestock market.

CEMETERY

The overcrowded churchyard at St John's made it an urgent matter to find a new area for burial, and the Knaresborough Cemetery was opened on 2 September 1876. It was, from that time until September 1974, administered by a Burial Board, who regulated opening hours and fees for graves, headstones, monuments and officiating ministers. Stonefall Cemetery, Harrogate, was not opened until 1914, with the first cremations taking place in 1937.

CHAFFEY DAM

Also known as Chappy Dam, and originally 'Chapman's Dam', referring to the mill it served. This is a weir on the Nidd with an ancient right of way across the river marked by stepping stones, although attempts to get this right restored by Knaresborough Town Council have so far failed. On 15 April 1917, a tragic accident here led to the death of a Royal Flying Corps pilot. (See Turnbull, Lt D.G.)

CHALONER, REVD DR ROBERT

(See King James's School)

CHAMBER OF TRADE

Founded in 1903, when its first president was William Bowler. The Chamber, first known as the Knaresborough Traders' Association, held a popular procession of decorated carts each summer during the early 1900s. The businessman who served as president of the Chamber no fewer than fifteen times (first in 1906, last in 1941) was Henry Eddy (q.v.). Also dating from the early 1900s is the Licensed Victuallers Association.

CHAPEL, ST ROBERT'S

(See Our Lady of the Crag)

CHARITIES

Many charitable bequests have been made over the centuries, recorded in wills and on the boards in the vestry of the parish church. In 1638, for example, Anthony Acham left £6 per annum for 'wheaten bread, to be distributed amongst the poor of the parish six times every year so long as the world shall

endure'. In 1647, Lord John Craven left £200, the interest from which was to be given to the poor of Knaresborough every Christmas. In 1651, this sum, together with £40 raised by the town, was used to buy 36 acres at Scotton, eventually producing the charity known as the 'Scotton Rents', later part of Knaresborough Relief in Need. Other bequests for the poor were from Andrew Holden, £20 (1707), William Yates, '78 twopenny loaves' (1807), and Henry Hopps, £100 (1840). Mrs Alice Shepherd had, in 1806, bequeathed £2,000 for the relief of 'poor industrious widows' and old people and £3,000 for 'putting out Boys and Girls to useful mechanical Trades'. In 1812, Dr William Craven added a bequest of £2,000 to this.

In more recent times, Knaresborough has been well served by local branches of national charities, including Rotary, Inner Wheel, the Lions and Age Concern, which in 2003 opened its new centre, Cliff House. Much charitable support has also been provided by the George A. Moore Foundation (q.v.). (See Charity School, Dispensary, Female Society, Cheap, Revd A., Marshall Suits, Penny Club, Stevens Bibles)

CHARITY SCHOOL
(See Richardson, Thomas)

CHARLES I
The son of James I, he was granted by his father the lordship of Knaresborough in 1616, nine years before he was crowned King. The castle and many Knaresborough people remained loyal to him through the upheaval of the Civil War. (See Siege, Slingsby)

CHARTER
The first known Charter was granted to Knaresborough by Edward II in 1310; its opening declaration was that 'Knaresborough be a Free Burg and the men inhabiting the same be Free Burgesses. They shall have one Market and one Fair, with the assize of bread and ale'. This last phrase means that the townsfolk had the right to fix a statutory price for staple food and drink. To the Earl (Piers Gaveston) and his heirs, the Charter granted hunting rights in Knaresborough Forest, as well as in the deer parks of La Haye (Haya Park), Bilton and Haverah, and the privilege of judging malefactors, with a gibbet and gallows. The inhabitants of Knaresborough were declared to be exempt from the payment of various tolls throughout the kingdom, and there is no

doubt that the Charter meant a considerable increase in status for the town. (See Burgage Houses, Fairs, Market, Gaveston, Piers)

CHAUCER, GEOFFREY

The famous poet had a connection with Knaresborough. In 1394 his sister-in-law, Catherine Swinford, married John of Gaunt, Lord of Knaresborough, who later appointed as Constable of the Castle a Thomas Chaucer, who was apparently the son of the poet and Speaker of the House of Commons.

CHEAP, REVD ANDREW

The second longest serving vicar of Knaresborough (1804–51), he was an evangelical with great social concern, and a champion of the poor. He was involved in the administration of the town's charities, including Richardson's School, instrumental in founding Castle Boys and Castle Girls School, and a trustee of the dispensary for Free Medicine. After he died in 1851, aged seventy-eight, a new Dispensary was built as his memorial in Castle Yard. (See Charities, Dispensary, Richardson's School)

CHILDREN'S DAY

Revived in 1972, this opened with the Children's Day Queen and her attendants being taken round the town. Then the queen was crowned by the mayor in the grounds of Knaresborough House before games and entertainment began. In 2003, Children's Day was organised by the Community Church on King James's playing field.

CHOLERA

Epidemics of this dreaded waterborne disease occurred in Knaresborough in 1832 (thirty-two deaths) and 1848–49 (thirty-eight deaths); the latter terrified the inhabitants of Harrogate, who read in the *Harrogate Advertiser*: 'It is within a few miles of us. At our own door, and the next hour may see us laid prostrate under its withering touch!' Raw sewage dumped in the Nidd, as well as open drains and dunghills, had not helped, and in 1850 a start was made on public sanitation by laying a main sewerage pipe down High Street. (See Sanitation)

CHURCHES
(See Catholics, Holy Trinity Church, Methodists, Parish Church, Quakers, St Mary's, United Reformed Church)

CIVIL WAR
The effects of this were certainly felt in Knaresborough, which had many inhabitants sympathetic to the Parliamentarian cause. Even before the war started, there was drunken rioting in the town when Charles I at last allowed an election in 1640, with complaints that the Royalist soldiers from the castle were terrorising the district by their wild and undisciplined behaviour. In 1642, Sir Henry Slingsby of Scriven Hall secured the castle for the King, handing it over to Sir Richard Hutton until Colonel Edward Croft was appointed commander. In June 1644, Prince Rupert, nephew to Charles I, led his troops north in an attempt to raise the siege of York. On the way he stopped briefly at Knaresborough Castle, and then faced Cromwell's army at Marston Moor, where, on 2 July 1644, the Royalists were heavily defeated. The captured Cavalier troops were marched through Knaresborough on 17 July, vilified and ill-treated by their Roundhead captors. This was just a prelude to the Parliamentarian assault on Knaresborough itself. (See Clubmen, Cromwell, Oliver, Siege of Knaresborough Castle)

CLARO
This was the name of the wapentake (the old subdivision of a shire) which included Knaresborough, as well as Harrogate, Boroughbridge and Ripon, extending as far as Middlesmoor to the north-west and Wetherby to the south. Though wapentake is a Viking word (a show of weapons for voting), Claro is a Norman name connected with Claro Hill, about 4 miles to the north-east of Knaresborough. Claro is possibly derived from Old French *clarion* – a trumpet or bugle, which was used to call people together. (See Sword Dance)

CLAYTON, 'BUNNY'
Educated at King James's Grammar School (1931–38), Bernard Clayton was an outstanding bomber pilot in the Second World War; his decorations included the DFC, CGM and DSO. He survived the war, but was tragically killed on a test flight in 1951.

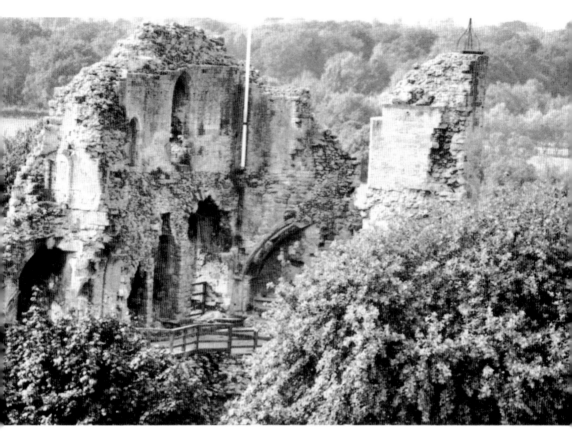

Knaresborough Castle.

CLUBMEN

So-called because they carried clubs and other rough weapons, these were groups of vigilantes like a Home Guard, keeping order during the disturbed period of the Civil War. The leader of the Knaresborough Clubmen was a prominent dyer called John Warner, evidently a Royalist, because he took refuge in the castle during the siege, and his son, Simon, was involved in a skirmish with Parliamentary soldiers, one of whom he is said to have killed.

COCK-FIGHTING

Once a common sport in Knaresborough, especially at the inns, several of which had a cockpit on the premises. One of the most skilled and enthusiastic participants in the mid-1700s was Blind Jack (q.v.).

COGHILL HALL

Originally this was Coghill House, a Tudor residence built by Marmaduke Coghill in 1555 on the site of an even earlier mansion. The Coghills, who later became united with the Slingsby family through marriage, included Sir John Coghill, Master of the High Court of Chancery in Ireland, and were for many years well-known as landowners, cloth merchants and Royalists. Coghill House was rebuilt as Coghill Hall, the home of Sir John Coghill. Then, in 1796, it was restored, enlarged and renamed Conyngham Hall (q.v.).

COLLINS FAMILY

A distinguished family closely associated with Knaresborough since at least the seventeenth century and mainly resident at Kirkman Bank and Knaresborough House. The Revd Thomas Collins was Knaresborough's longest-serving vicar, being incumbent here from 1735 to 1788. He was, for many years, a governor of King James's School and much involved in the life of the town, having associations with characters such as Blind Jack and Eugene Aram. His most important contribution was in connection with the parish church (q.v.). He is not to be confused with a later relation (also a Revd Thomas Collins), whose son, Tom Collins, a barrister, was first elected as a Conservative MP for Knaresborough in 1851, and who was soon nicknamed 'Noisy Tom' because of the constant interruptions he made in the House of Commons. Colonel W. F. Collins was a magistrate and chairman of the bench for twenty-five years. His wife, Lady Evelyn Collins, a cousin of Winston Churchill, served as chairman of the council and of the governors of Knaresborough Grammar School. In 1951, she sold her home, Knaresborough House, to the Council. Her son, Sir Arthur Collins, along with his wife, Lady Elizabeth, did much to support Knaresborough, in particular as president of the British Legion. He died in 2001, the last of the line, after a long life in the service of his country and community. There are interesting memorials to the Collins family on the north end of the west wall of the parish church.

COLLINS COURT

This sheltered home, pleasantly situated in the grounds of Knaresborough House, was opened by Lady Elizabeth Collins in 1984.

COMMUNITY CENTRE

Opened by the Council in 1957 on the King George V Playing Field, Stockwell Avenue. It was originally for the children of Council tenants, who paid towards

it with an extra twopence a week on their rent. The chairman from 1959 to 1972 was Richard Hyman, and from 1975 to 1999 Barbara Fabretti. A new community centre was opened on the same site in 1998.

CONGREGATIONAL CHURCH

(See United Reformed Church)

CONYNGHAM HALL

Based on the old Coghill Hall, which had been rebuilt in the 1760s, probably by John Carr, this was sold, with 51 acres of land along the Nidd, by Sir John Coghill to Ellen, Dowager Countess of Conyngham, hence the name. In 1905, it was bought by the Charlesworth family. Sir Harold Mackintosh, the Toffee King, lived in Conyngham Hall from 1924 to 1942. In 1946, the hall and grounds were bought by the Knaresborough Urban District Council. (See Coghill Hall, Dogs' Graveyard, Mackintosh, Sir Harold, Toffee Park)

COUNCIL

(See Town Council, Urban District Council)

COUNCIL OFFICES

Purpose-built for the Knaresborough Urban District Council, these were opened by Councillor Thomas Stead in 1910 at the corner of York Place and Gracious Street, a stone building enhanced by the Knaresborough emblem sculpted in stone. The offices were used by the Council until the move to Knaresborough House in May 1951.

COURTS

(See Honour of Knaresborough, Old Courthouse, Sessions House)

CRICKET

Knaresborough Cricket Club, one of the oldest in Yorkshire, was founded in 1815. By 1849, it had such a formidable reputation that no local club would compete against it, and Knaresborough issued a challenge to any team within a 30-mile radius, eventually playing against clubs from Leeds, Bradford, York

and Hull. When Knaresborough beat Sheffield, then Yorkshire's most famous team, it included fast bowlers such as Jonathan Joy and George Freeman; the latter was described by W. G. Grace as the finest bowler he had ever played against.

In 1863, Knaresborough Cricket Club first played on the field at the top of Aspin Lane, exchanged in 1964 with King James's Grammar School for the present grounds at the bottom of Aspin Lane. From about 1905 the club was in decline, but it was revived in 1909 by Councillor Henry Eddy, gradually recovered its prestige, and in 1978 won all five trophies in the Airedale and Wharfedale Senior Cricket League. Other cricket clubs have been associated with the schools, churches, Conyngham Hall and Calcutt. The Knaresborough Forest Club, which had started out as the Liberal Club team, moved in the late 1940s to their present field behind the Union Inn, which had been used by the Calcutt Cricket Club.

CROMWELL, OLIVER

Although Cromwell was not present when his Parliamentarian forces took Knaresborough Castle in 1644 (see Siege), he took an interest in the town. After his victory at Marston Moor (1644), he was remembered for his kindness to the widow of Colonel Townley, who had come to find her Royalist husband's body on the battlefield. Cromwell later stayed in Knaresborough in 1648, when the castle was being officially dismantled. Cromwell House in High Street was largely rebuilt, but the floor of the bedroom where he slept was carefully retained. This was partly because of an eye-witness account by Eleanor Ellis, daughter of the house, who had taken up a warming-pan to air Cromwell's bed, then peeped through the key-hole to watch him as he knelt in prayer.

CROSSBOW BOLTS
(See Quarrels)

CROSSES
(See Birnand Cross, Knaresborough Cross, Market Cross)

CURFEW BELL
A custom which survived in Knaresborough until the middle of the nineteenth century was the ringing of the curfew bell from the parish church at eight

Oliver Cromwell taking time out from civil warring.

o'clock every night. Going back to Norman times, the curfew originally ordered the extinguishing of fires (from Old French *couvre-feu*).

CYCLING CLUB

The Knaresborough Cycling Club was founded in about 1883, the year of the introduction of the Otto velocipede, with two huge wheels and a saddle in between, shown in a rare photograph of the club. They met at the Elephant & Castle, and were organised by a committee, led by a captain, two sub-captains and a secretary. Members paid 2s 6d per annum, wore a club cap and badge, and won prizes on long-distance runs. They were led by the captain, who signalled instructions by giving bugle calls.

DANYELL BRIDGE
(See High Bridge)

DEANE, EDMUND
The first known publicist of Knaresborough, Edmund Deane, a York physician, praised the town as the ideal base for 'taking the waters' at the various wells in the district, principally those at what later developed into the two hamlets of High and Low Harrogate. In his book *Spadacrene Anglica* (1626), Dr Deane says of what was then being called 'Knaresborough Spa': 'Both the Castle and the Towne are fenced on the south and west with the River Nidd, which is beautiful here with two faire bridges of stone. About the towne are divers fruitful valleys, well replenished with grasse, corne and wood. The waters there are wholesome and clear, the ayre dry and pure. In brief, there is nothing wanting that may fitly serve for good and commodious habitation, and the content and entertainment of strangers.'

DEFOE, DANIEL (1660–1731)
Stayed in Knaresborough in about 1717, and talks of the 'wonderful strangeness of this part' in his *A Tour Through the Whole Island of Great Britain*. He later described how he had been out to visit the wells on Harrogate Stray, and been surprised at the large numbers visiting this 'most desolate out-of-the-world place', remarking how he had heard that 'men would only retire to it for religious mortifications, and to hate the world, but we found it was quite otherwise'.

DINSDALE'S
Traditional grocer's in the Market Place, established in 1849. Though it closed down in 1965 (replaced by Heapy's radio and video shop until 2003), Dinsdale's is still remembered for its aroma and atmosphere – old-style scales, bacon slicer, coffee grinder, hams and flitches of bacon hanging from the ceiling, and everything personally cut and weighed, wrapped, and delivered if required.

DISPENSARY
Knaresborough's original dispensary of free medicines was at the top of Castle Ings, where it had been started in about 1803 by Dr Peter Murray. In 1853, a new dispensary was built as a memorial to the vicar, the Revd Andrew Cheap,

as is indicated by the inscription carved into the stone of its frontage. As a kind of forerunner of the National Health Service, doctors and nurses here provided free advice, treatment and medication to those who could not afford to pay. The Dispensary was supported mainly by public subscription, with special collecting boxes placed in the town's pubs, restaurants and shops. (See Cheap, Revd Andrew, Murray, Dr Peter)

DOGS' GRAVEYARD
Situated in the grounds of Conyngham Hall, to the left of the path from Henshaw's, this graveyard consists of at least twenty-three graves of favourite dogs, with little headstones from the days of the Woodds, the Charlesworths (post 1905) and the Mackintoshes (post 1924). The inscriptions include: 'Tiger (1859)', 'Cora (1862)', 'Kelpie (1873)', 'Sweep (1875)', 'Jack (1877)', 'Queenie – Semper Fidelis (1879)', 'Rover (1919)', and 'Dear Old Dandy – Died 1932 aged 14'.

DOMESDAY
This tax survey ordered by William the Conqueror in 1086 shows that Knaresborough – spelt Cenaresburgh (French had no 'k') – was in a poor state following the suppression and devastation at the hands of the Normans. Knaresborough and its berewicks or associated villages are described as having 'land for 24 ploughs. King Edward had this manor. Now it is the King's land, and is waste. In King Edward's time the value was six pounds. It now pays twenty shillings.'

DONKEY DAVE
From 1955, for almost forty years, the donkeys kept by David Allott gave rides along the banks of the Nidd near High Bridge. The donkey-rides at first cost sixpence, and at Donkey Derbies much money was raised for charity. At Mr Allott's funeral in 1993, it was a moving sight to see the cart bearing his coffin pulled by one of his favourite donkeys. David Allott's story is told in *The Donkeyman*, written by his eldest son, Philip.

DORSET, ALEXANDER DE
The vicar of Knaresborough from 1205 to 1233, appointed by King John, who then disregarded the rights of Nostell Priory. Alexander de Dorset, also a

royal clerk and administrator, seems to have been well favoured by the King, collaborating with him in spite of the Pope's interdict banning all church services (see Royal Maundy) and extending the early parish church in the beautiful Early English style (see Parish Church).

DOWER HOUSE

Situated at Bond End, the Dower House, now a hotel, though Georgian in appearance, has some Elizabethan work inside, and goes back to the time when it was customary to provide a home for a dowager to retire to when her eldest son succeeded as head of the family. A dower was the widow's share of her husband's estate, in this case that of the Slingsby family, whose seat was at nearby Scriven Hall.

DRAYTON, MICHAEL

One of the earliest writers to describe Knaresborough, this poet in his 'Polyolbion' (1612) praises 'the nimble Nyde' which:

> Through Nyderdale along, as neatly she doth glide
> Towards Knarsburg ... where that brave Forest stands,
> Entitled by the Town

DROPPING WELL

One of Britain's oldest tourist attractions, this petrifying well derives its name from the water dropping over a limestone rock into a little pool before joining the Nidd. The earliest known description is by John Leland, the antiquary of Henry VIII. After his visit in about 1538, he wrote of 'a Welle of a wonderful nature, caullid Droping Welle. For out of the great rokkes by it distillith water continually into it ... what thing so ever ys caste in and is touched of this water, growth ynto stone.' A tourist attraction since 1630, the Petrifying Well has intrigued visitors with its seemingly magical ability to change everyday objects into stone by depositing layers of calcite. Seven hundred gallons of water flow through every hour and it takes approximately six months to 'petrify' a teddy bear, for example. Today, the well features a highly imaginative array of articles, some of which are in the museum. Nowadays, the overhang is regularly scraped to prevent collapse, as happened in 1704, 1816 and 1823. Neither Leland nor any other early visitor refers to a nearby cave, later claimed to be the birthplace of the Tudor prophetess Mother Shipton, though the two are now closely associated.

The Dropping Well Estate, covering 12 acres, with the Long Walk and its beautiful views of Knaresborough across the river, was owned by the Slingsby family until 1916, when it was sold off by auction. The Long Walk was used by Madame Doreen – palmist and clairvoyant – who gave special consultations by appointment. It was bought in 1986 by a company then headed by Frank McBratney and Paul Daniels, and its name was changed to Mother Shipton's Cave, Ltd. In 2001, it was taken over by Adrian and Elizabeth Sayers. (See Long Walk, Mother Shipton, Slingsby Family)

DUNGEON

The best-preserved part of ruined Knaresborough Castle, looking almost exactly as it must have done when the keep was completed in 1312. It has a central pillar from which radiate twelve graceful arches, like the underside of a mushroom, and is said to be the only dungeon in the country with this structure. Though also used as a storeroom (literally a 'cooler'), it certainly held prisoners, as can be seen from medieval graffiti cut into the stone. The single window is tiny and the walls are 15 feet thick. There is a legend that prisoners, manacled to the wall, were moved round until they came into the shaft of light from the window – and then they were taken out and executed. We may doubt this tale, but not the claim that no prisoner ever escaped from this fearsome dungeon.

DYE-HOUSE

Dyeing was an important part of Knaresborough's textile trade, mainly in flax and linen. The best-known dyer was John Warner, whose former dye-house can be seen at the right of the bottom of Gallon Steps. The inventory made at his death in 1657 includes a wide range of colours, such as indigo, woad, logwood, madder and 'scuttin neeale' (cochineal), as well as the all-important mordant, alum. The dye-house also contained nearly 900 yards of cloth. The business was carried on by Simon and Thomas Warner, then by William Ibbetson (see Tenter Lodge), but eventually declined. In more recent years, the dye-house was used by Sturdy's for storing boats, and in the 1960s it housed a small children's zoo. (See Boating, Clubmen, Linen Industry)

EDDY, HENRY

Although well-known as a boot and shoe retailer, with his shop in the Market Place, Henry Eddy is even more famous as a benefactor and champion of

Knaresborough. He served as chairman of the Urban District Council from 1919 to 1923, and again in 1936 and 1939. A County Alderman and JP, his outstanding public service was recognised by an OBE in 1937. The following year, he took over as chairman of the Governors of King James's Grammar School, which he had already served with enthusiasm and enterprise for thirty-one years. It was fitting that it was almost adjacent to the school that he built his house, Eddystone.

EDWARD II

Though he had few successes, this monarch could be said to have brought considerable benefit to Knaresborough. In 1310, mainly because he had appointed his notorious favourite, Piers Gaveston, Lord of Knaresborough, he granted the town its first known Charter. He also authorised the complete rebuilding of Knaresborough Castle on the site previously developed by King John. In January 1312, King Edward had to take refuge in Knaresborough Castle because of the rebellion led by his cousin, Thomas, Duke of Lancaster. The latter refused to support the King when, in 1314, he marched north to raise the siege of Stirling. From York, he had issued orders to all men between sixteen and sixty to join his army. These included men from Knaresborough, among them William de Vaux, Constable of the Castle. He and many townsmen lost their lives in battle when Edward was soundly defeated by Robert the Bruce at Bannockburn. (See page 23)

EDWARD III

King Edward stayed several times in Knaresborough Castle, notably in January 1328 after his marriage to Queen Philippa in York. There are references to Edward III breeding horses in the 'Park de la Haye' (Haya Park) and hunting deer and boar in the Forest of Knaresborough. In 1355, he was attacked by a boar he had wounded, and was thrown from his horse. His life was saved by Thomas Ingilby of Ripley Castle, who killed the animal; he later received a knighthood, and a boar's head was henceforth included in the Ingilby arms. (See Haya Park, John of Gaunt, Queen Philippa)

EDWARD VII

His coronation in 1902 was commemorated by the joiner and undertaker Benjamin Woodward, who called the house he built that year, 45 Kirkgate, 'Coronation Cottage' and added the coloured plaque of the King, still to be seen.

EPITAPHS

The crowded churchyard of St John's parish church contained many interesting inscriptions, most of which were transcribed before the gravestones were removed or lost in the radical landscaping of 1973. These range from a memorial to 'the agreeable and good Mrs. Dove', who died in 1759, aged ninety-nine, to heartbreaking records of infant mortality, so common in past generations. For example:

Stranger, tread soft – 'tis hallowed ground,
Two lovely infants here have found
 A bed of rest;
They came, they caus'd a smile, a tear;
Then 'scaped from sorrow, pain and fear
 And joined the bless'd.

ELECTIONS
(See Parliamentary Elections)

FAWKES, GUY

Born in York in 1570, Guy Fawkes came to live in the Knaresborough district in his late teens. This was when his widowed mother married Dennis Bainbridge of Scotton, a Catholic who lived in Percy House, Scotton, and also at Scotton Old Hall. Guy had been brought up a Protestant, but the illegal Catholic religion of his new relations, some in Knaresborough itself, led to his conversion. The marriages of Guy's two sisters are recorded at Farnham parish church, and although he signed himself, 'Guye Fawkes of Scotton … gentle-man', in about 1593 he moved south and eventually joined the Spanish army then fighting in the Netherlands.

As Captain Guido Fawkes he had a distinguished military record, and his expertise with explosives led the plotters to recruit him in their attempt to assassinate James I. It has been claimed that the plot was made around a table which was kept in a Knaresborough inn, but this is, in fact, an antique once bought in modern times by the owner of Scotton Old Hall. It is true, however, that most of the conspirators had family connections with Lower Nidderdale.

Guy Fawkes, calling himself Johnson, a servant to Thomas Percy, smuggled thirty-six barrels of gunpowder under the House of Lords, ready for its royal opening on 5 November 1605. Just before midnight he was arrested, 'booted and spurred', ready to make his getaway, having on his person a watch, lantern, tinder-box and slow fuses. He was interviewed by King James in his

bedchamber, taken to the Tower to be tortured, and finally 'hanged, drawn and quartered' as a traitor on 31 January 1606. Though he is still burnt in effigy on 5 November ('Plot Night', as it is called in parts of Yorkshire), no Guy is ever burnt at St Peter's, his old school in York, or on the public bonfire in Scotton.

FEMALE SOCIETY

A Knaresborough charity started in 1809 to 'afford a comfortable and necessary relief to lying-in women' – i.e. expectant mothers. Run by a committee of twelve, the Female Society provided gruel, bread and coals for a month, together with linen and clothes for the new-born child.

Feva

Knaresborough's annual festival of Entertainment and Visual Arts. Every August, over ten days, the town stages a marvellous programme of shows and events, which might include photography and art exhibitions in the Boat House, a play in the park or music in the pub. From street theatre to open-air concerts, from live music to the art trail, there is always something to suit all ages, and all tastes. Previous events have, for example, featured Roger McGough, Gervase Phinn and Sophie Hannah.

FIENNES, CELIA

The lady who rode side-saddle through England and was the first to visit every county in the land reached Knaresborough in 1697 and 1698. Describing Knaresborough on her extraordinary tour in *Through England on a Side-Saddle*, she admired 'the little houses ... all built in the rocks', the Crag Chapel, the castle ruins and a 'Cherry Garden with green walkes for the Company to walk in'. She went to Harrogate 'on a Common that belongs to Knaresborough, all mossy and wet'. She described the Stinking Spaw (the Old Sulphur Well) as 'not improperly term'd, for the Smell being so very strong and offensive I could not force my horse near the Well'. The waters were 'a good sort of Purge if you can hold your breath so as to drink them down'. She also visited the Dropping Well and St Mungo's Well at Copgrove. (See Spa, Knaresborough)

FINKLE STREET

The original name of what in the eighteenth century was called Swine Market, from the many pigs sold here. There are Finkle Streets in other northern towns,

and the name could be derived either from a Viking word meaning 'angle', 'corner', or a Middle English form of 'fennel'.

FIRE BRIGADE

An early fire brigade certainly existed in 1774, the date of the hand-pumped engine preserved in the Courthouse Museum along with some of the old leather fire-buckets. Responsibility for an official fire brigade was taken over by the Improvement Commissioners in 1860, when the Town Surveyor was put in charge of the fire engine. This used to be kept behind the Borough Bailiff, where the bell they used to summon the brigade can still be seen. Later the Town Hall bell was used, and the engine kept in the drill hall, Chapel Street. There were usually about ten firemen, mostly drawn from trades useful in fire-fighting, such as slaters, blacksmiths, plumbers and joiners. They were unpaid volunteers, receiving only what might be paid out by an insurance company. The modern fire service later moved to Gracious Street, where a purpose-built station opened in 1956.

FIRST WORLD WAR

Like every other community, Knaresborough passed through the four harrowing years (1914–1918) of the First World War. The first Knaresborian to volunteer for the army was John Taylor, at a recruitment drive in the Market Place; the first to be killed in action was Private Walter Malthouse, on 9 May 1915, aged twenty-one. By 1918, 156 Knaresborough men had lost their lives in battle. A casualty in Knaresborough itself was Lt D. G. Turnbull of the Royal Flying Corps (q.v.).

The civilian contribution included all kinds of fundraising for the war effort, such as a concert in 1915 by the band of the Royal Scots Grays, whose commanding officer was the distinguished Knaresborian Colonel William Fellowes Collins, D.S.O. His wife, Lady Evelyn Collins, was Matron of Knaresborough Hospital (the former Workhouse), which looked after convalescent wounded servicemen. Convalescent soldiers were also housed in Conyngham Hall. (See Hospitals)

Knaresborough's acknowledgement of the sacrifice made by those who served in the war was made in a special Certificate of Appreciation. The one presented to William Henry Dawes, signed by Henry Eddy, chairman of the KUDC, reads: 'This Ancient and Royal Borough of Knaresborough is proud of its heroes, and its townspeople tender you their grateful thanks.' (See British Legion, War Memorial)

FITZ-JOHN, EUSTACE

Lord of Knaresborough until his death in 1157, when he was killed in battle fighting the Welsh. A nephew of the castle's founder, Serlo de Burgh, it is recorded that he spent, for example, 'eleven pounds on the King's work at Chenardesburg', which must refer to his development of the castle. It is also recorded that in 1133, when Fitz-John heard that the Cistercian monks who had started to build Fountains Abbey were dying of starvation, he sent them from Knaresborough 'a cart-load of fine bread'.

FLAX

(See Linen Industry)

FOOLISH WOOD

The wood overlooking the Nidd, opposite Conyngham Hall, was part of the royal hunting ground. Its odd name is probably derived from 'foal-house close', suggesting this was where horses were bred.

FOOTBALL

(See Knaresborough Town Football Club)

FOREST OF KNARESBOROUGH

A vast royal hunting-ground established by the Normans, first mentioned in the Pipe Rolls of 1167. It extended westwards from Knaresborough for some 20 miles, and covered 100,000 acres. It was not, as is often assumed, entirely wooded, but a much more open area, including many villages. There are ample documentary references to the practice of farming, fishing, wood-cutting, charcoal-burning, iron-smelting, corn-milling, and the hunting (and poaching) of game birds, wild cattle and boar, and especially deer. The latter was so successful in the forest that a hunt could yield as many as 100 deer, instead of the more usual 50. (See Edward III, Honour of Knaresborough, John of Gaunt, King John)

FORESTERS, ANCIENT ORDER OF

Founded as the Royal Foresters in Knaresborough Castle, 29 October 1745, this Friendly Society can claim to be the oldest of its kind in the world. The

official history of the organisation starts in 1790, when Court No. 1 was opened in Leeds. The titles of officials, however, continued to be reminiscent of the forest – Ranger, Woodward and Beadle, the latter acting as doorman to check the password. In 1813, Leeds granted a dispensation to a Quaker flax-dresser, John Smithson, to found Court No. 2 in Knaresborough. This closed down in 1825, but a revival, Court No. 506, was started in 1837, and this still holds regular meetings in Knaresborough House.

FORT MONTAGUE
(See House in the Rock)

FOUNTAIN, JOSEPH BAKER
Painter of the Knaresborough scenes of his boyhood, Joe Fountain was born and bred in Knaresborough, attending Castle Boys' School before the First World War, becoming a skilled bricklayer, doing various jobs in South Africa and Devon, then starting an antiques shop in Knaresborough in 1963. He did not start painting until he was fifty-two, but by his death in 1992, aged eighty-four, he had produced more than twenty pictures of Knaresborough social life set in the early 1900s. In the 'primitive' style, his views are minutely observed and faithfully depicted; his 'Knaresborough Market', for example, includes around 300 tiny figures. The paintings, some exhibited at the Royal Academy, are preserved in the Mercer Gallery, Harrogate.

FOX, GEORGE
(See Quakers)

FRAZER THEATRE
Named after F. R. Frazer (see Friendship and Leisure Centre), director of Nidd Vale Motors, who first leased the hall to the town, this building occupies the site of the ballroom of the demolished Elephant & Castle, which was previously used for boxing, and also as a skating rink. In 1962, it was adapted as the town's own little theatre, later also as a cinema, and extended in 2009. (See Knaresborough Players)

FREEMASONS

Two early lodges are known to have existed in Knaresborough – the Crown Lodge (consecrated in 1769), which met at the Crown, and the Newtonian Lodge (around 1785), which met at the Elephant & Castle. These were eventually disbanded, but then the Knaresborough Priory Lodge (1920) first met in the Old Town Hall, and later in Fysche Hall, opened in 1930 by Lord Harewood as a Masonic Hall, and also used by other Masons, including the Forest of Knaresborough Lodge (1956).

FRIENDLY SOCIETIES

In addition to the Foresters (q.v.) and Oddfellows (q.v.), Knaresborough had other mutual aid societies by the 1890s, including the Druids, who met at the Crown, and the Free Gift, which met at the Queen's Arms in Jockey Lane. From 1919, the Royal Antediluvian Order of Buffaloes started to meet in the Wellington, then the Hart's Horn, then the Crown.

FULLING MILLS

Important in Knaresborough's textile industry, the process of fulling – thickening cloth – was carried out in various fulling-mills, sometimes known as 'walk-mills' because a 'walker' fulled the cloth by tramping on it. The first known mention of a fulling mill in Knaresborough was as early as 1284. One was built at Spitalcroft in 1525, and apparently survived until 1849, when it was shown on the OS map as a 'walk mill'.

FYSCHE HALL

This is a bogus old-world spelling of what in early documents is described as Fysh or Fish Hall. It was the home of the wealthy Francis Iles (died 1776), who was suspected of being involved in the fraud connected with Daniel Clark (see Eugene Aram). His marble tombstone in front of the altar steps in St John's parish church was unfortunately removed during alterations, but Iles Lane preserves his name. In the following century, Fysche Hall was the home of H. G. Christian, former Governor of Bombay, who is commemorated in the east window of the parish church.

GALLON STEPS

The ninety-six steps leading from the bottom of Kirkgate to Waterside do not, as is sometimes said, derive their name from water being carried up from the

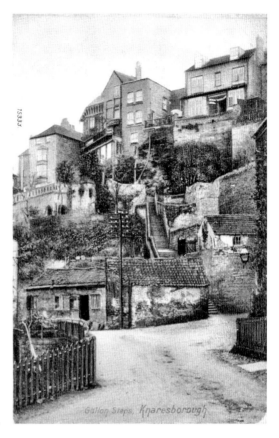

The Gallon Steps.

river (see Water Bag Bank), but are named after Mr Richard Nicholas Gallon, born in 1789, who lived in the house at the top, Nidd Pavilion, and later moved to Hawkshead, Cumbria, where he died in 1834.

GAS LIGHTING

Soon after their formation in 1823, the Improvement Commissioners appointed the engineer John Malam to build the town's first gasworks on Waterside, near Low Bridge, at a cost of £6,000. The first gas lamps were lit on 13 September 1824, making Knaresborough one of the earliest towns to have good street lighting (Harrogate did not have gas lighting until 1845). To celebrate his achievement, no doubt, Malam, at his own expense, replaced the eroded Market Cross with a gas lamp in 1824. By 1841, he had installed 94 public gas lamps, and by 1864 there were 129, with many homes gas-lit. In 1958, there were still 200 street gas lamps in Knaresborough. The town's last lamp-lighter, John Flynn of Halfpenny Lane, retired in 1975.

GATES HILL

A campsite of unknown age near Scotton Banks, which is in a commanding position high above the river. The Parliamentarian troops under Fairfax camped and trained here in 1644, but the story that they fired their cannon at Knaresborough Castle from here is far-fetched. (See Siege)

GAVESTON, PIERS

Exiled by Edward I because of his corrupting influence on his son, this French-speaking Gascon was recalled to England after the King's death. Edward II not only broke his promise to his father, but also promoted his favourite Earl of Cornwall and Lord of Knaresborough. To please Gaveston, he then authorised the complete rebuilding of Knaresborough Castle, turning it into a palatial residence. He also, in 1310, granted the town a Charter, in which Gaveston's privileges and hunting rights were established. Though Piers Gaveston brought certain advantages to Knaresborough, he was generally unpopular, and few can have been sorry when, in May 1312, he was besieged in Scarborough Castle by rebellious barons and later beheaded near Warwick; his head was sent to the King. (See Castle, Charter, Edward II)

GEORGE V

The new King's popularity in Knaresborough is shown by photographs of a crowded Market Place listening to the Proclamation in 1910 and the Coronation Celebrations in 1911, when the town was bright with flags, bunting, ladies in their finery, and soldiers of the West Yorkshire Regiment.

GEORGE VI AND QUEEN ELIZABETH

The Coronation was celebrated in Knaresborough (12 May 1937) with a service, a parade, a children's tableau by Jim Kell, with the crowning of a child king and queen by Alderman Eddy, and an address by Sir Harold Mackintosh, followed by sports, entertainment, free tea 'for the Old Folks' and the Silver Band and fireworks in the castle grounds.

GHOSTS

As with many old towns, Knaresborough has its share of apparitions and hauntings. From my own collection of reported phenomena over the years, I would say the most consistent tradition is that of the White Lady, said to have

Leaving Goldsborough Hall.

been seen in the castle area, which is also associated with sightings of monks and soldiers. Other places claimed to be haunted include the Free Dispensary, the former Tudor Café (12 Market Place), parts of Silver Street, Manor Cottage, the Old Manor House, the ice-house of the Dower House, the old chapel (High Street), and various pubs, notably the Old Royal Oak, Market Place.

GOLDSBOROUGH

As it is so close to Knaresborough, the village of Goldsborough has had a long historical association with the town. Its most notable features are the parish church of St Mary's, with its fine Norman doorway, remarkable windows and fourteenth-century tombs, and the adjacent Goldsborough Hall, built in about 1625 by Sir Richard Hutton, Recorder of York and a trustee of King James's School. His son, also Richard, was an MP for Knaresborough in 1625 and High Sheriff of Yorkshire in 1642. The most famous residents of the Hall were the Lascelles family, especially after Edward Lascelles was created Earl of Harewood in 1812. When Princess Mary, the Princess Royal, lived at

Goldsborough Hall, she often came to Knaresborough, opening a new wing of Knaresborough Hospital, for example, in 1925. (See Chaloner, Revd Dr Robert)

GOLDSBOROUGH HALL

In March 2010, the 11 acres of gardens were opened to the public for the first time since 1930; this was a dress rehearsal for its opening in July 2010 as part of the National Garden Scheme.

GOODRICKE FAMILY

Associated with Ribston Hall from 1542. Sir Henry Goodricke, a notable Royalist supporter, in 1688 helped to secure York for the Prince of Orange and then marched into Knaresborough Town Hall, sword in hand, proclaiming him King William III, 'our deliverer from popery and slavery'. (See Ribston Hall)

GRACIOUS STREET

Because there have been (and still are) several places of worship on or near Gracious Street – United Reform Church, Quaker, Methodist and Anglican – it has been incorrectly assumed that 'gracious' is an appropriate name derived from the presence of chapels and churches. The name, however, is derived from Anglo-Saxon *gracht hus* (literally 'ditch houses'), and refers to houses built on what Hargrove described as the town's main ditch, or defensive moat, which became an open sewer. This ran along what is now Gracious Street, and which in the nineteenth century was even called Grace Church Street.

GRIMBALD BRIDGE

Named after the nearby Grimbald Crag, towering above the river, 'Grimbald' is said to have been the name of a hermit. Grimbald Bridge is first mentioned in history as the headquarters of a great army assembled in 1407 by Sir Thomas Rokeby, Sheriff of Yorkshire, who had been ordered by Henry IV to stop the march of rebel troops northward. The battle took place at Bramham Moor and the rebel army was outmanoeuvred, with a victory for the King. Grimbald Bridge was in the news again in 1800, when a survey for two possible canal routes was made, both starting at the bridge, intended to link the Nidd with the Ure or the Ouse.

HARGROVE, ELY
Knaresborough's first known local historian, author of *The History of the Castle, Town and Forest of Knaresborough, with Harrogate and its Medicinal Waters*. This first appeared in 1775, and went through several editions, with slight updating, until the seventh edition of 1832. Though lacking a systematic and thorough approach (Knaresborough occupies only 67 pages of 316 in the 1789 edition, many being devoted to nearby villages and towns), Hargrove's history nevertheless contains much valuable information on the town where he ran his High Street printer's and bookshop, later Parr's. He died in 1818, aged seventy-seven, and his tomb can be seen near the chancel door of St John's parish church.

HAYA PARK
Enclosing deer and boar for hunting, and also cattle and horses, this area to the east of Knaresborough was founded by the Normans as the *parc de la haie* (hedge). It covered 1,500 acres and contained nearly 300 deer in the fifteenth century; sold off by Charles I in 1628, it was later owned by Sir John and Lady Hewley; the latter was an important supporter and benefactress of Knaresborough's early Independent Chapel. (See Edward III, United Reformed Church)

HENSHAW'S ARTS & CRAFTS CENTRE
The award-winning Arts & Crafts Centre is part of Henshaws Yorkshire, a charity offering practical help, support and services to people of all ages affected by sight loss. The Centre provides a fully accessible, stimulating environment in which visually impaired people can learn new skills and express themselves through art and creativity. Workshops include woodwork, music and drama, papermaking and jewellery, and are open to the public. The Centre also has a gallery holding regular exhibitions, a fully licensed café and a sensory garden to explore. A shop and a plant nursery sell products and plants made and grown by service-users at the Centre and students from Henshaws College.

HEWITSON COURT
Sheltered housing in Stockwell Road, opened in 1986, named after Councillor P. W. Hewitson, who had died in office the previous year.

Henshaw's Arts & Crafts Centre.

HIGH BRIDGE

Originally called Danyell Bridge, this grew in importance as Harrogate developed, and was enlarged in 1773 and 1924. (See Low Bridge)

HILL, THOMAS

In January 1791, 'Sir' Thomas Hill was charged by His Majesty's Command as follows: 'you shall faithfully serve, watch and maintain our commands against any lawless audacious depredators, robbers and night strollers who dare villainously assemble themselves ...' (See House in the Rock, Nancy Buckle)

HOKETIDE
(See Vikings)

HOLCH, GEORGE ALBERT
Well-known as the son of George Holch, the pork butcher, whose family had moved to the Market Place shop from Castleford soon after the First World War. He succeeded his father in the business and became an outstanding worker for the community. He was six times chairman of Knaresborough Urban District Council and held many other offices in the town, and was made an Alderman of the Harrogate District in 1974. Albert Holch was chairman of the Governors of King James's School from 1956 until his death in 1977. The Holch Memorial Garden, adjacent to Knaresborough Methodist church in Gracious Street, where he was a keen member, was opened in his memory by Mrs Alice Holch in 1980. (See Town Twinning)

HOLDEN, SIR ISAAC
Pioneer of the woollen industry who worked with S. C. Lister, he was a keen Methodist, substantially supporting the new chapel in Gracious Street (1868). Though based in Keighley, he stood as Liberal candidate for Knaresborough in the 1865 elections. Addressing the crowd of 2,000 from the Town Hall balcony in the Market Place, he saw that the vast majority raised the hands in his favour. In the actual vote, he was narrowly elected one of Knaresborough's two MPs, but described the cheers of his supporters as 'the shouts of freemen just delivered from bondage'. (See Methodists)

HOLY TRINITY CHURCH
This was built as an addition to St John's when the population of Knaresborough grew big enough to merit the formation of another parish with its own parish church. Situated at the top of the town, just off Briggate, Holy Trinity has become, with its 166-foot spire, a landmark visible for miles around. Designed by Joseph Fawcett in the modern Early Decorated style, it was built at a cost of £3,800. Consecrated by the Bishop of Ripon, the church opened in 1856.

Though the steeple was designed to take a clock and could hold a full peal of eight bells, only one bell materialised, the gift of Basil Woodd (q.v.) of Conyngham Hall (later replaced in 1994 by the bell from Thistle Hill chapel). Holy Trinity, a Grade II Listed Building, possesses well-designed Victorian and Edwardian items, such as the font of Caen stone donated by Knaresborough-

born Revd Dr W. Kay, and the Norman arch facing Cheapside, provided in 1905 by Miss Margaret Collins in memory of the first vicar, the Revd E. J. Ramskill. The choir stalls are in memory of Miss Lucy Collins.

There are some fine Victorian windows, including the East Window, costing £270, raised by public subscription, unveiled as a memorial to Prince Albert in December 1862. Other windows include those in memory of the Revd James Fawcett, who was chiefly responsible for building the church, and Samuel Powell, the solicitor. In 1993, the west door was replaced by a modern stained-glass window.

HONOUR OF KNARESBOROUGH

Medieval term referring to the lordship of Knaresborough, which consisted of three sections, each with its own court: the Manor or Borough of Knaresborough itself, the Forest of Knaresborough and the Liberty of Knaresborough, which covered a dozen villages to the north and east. The Honour Court, with its separate juries, met in Knaresborough every three weeks, holding an additional Sheriff's Town for county matters, the Michaelmas Tourn appointing the township constables, and officers such as the Grave and Beadle of the Forest.

HOSPITALS

The earliest known of these are thought to have been leper hospitals set up by the friars of Knaresborough Priory (q.v.), as is suggested by the name Spitalcroft. The first Knaresborough Hospital was an adaptation of the 1858 workhouse in Stockwell Road. It was used as a military hospital for convalescent servicemen during the First World War, when Lady Evelyn Collins was Matron and Dr I. D. Mackay and later Dr W. J. Forbes were the medical officers. In 1925, the Princess Royal, of Goldsborough Hall, opened a new wing. There were separate nurses' quarters, with a maternity ward and a children's nursery. In the 1930s, the Master and Matron were the Alexanders, whose son Terrence became well known through the *Bergerac* TV series. Knaresborough Hospital developed as a modern geriatric unit, but in 1996 it was closed and its attractive mock Tudor building demolished. (See Workhouse)

Conyngham Hall had been used as a military hospital during the Second World War. In 1937, a sanatorium was built at Scotton Banks. When the need for the treatment of tuberculosis declined, this was adapted for use as a general hospital. It was demolished in 1990 and replaced by residential development.

HOUSE IN THE ROCK

Built into the crag overlooking Low Bridge, this unique dwelling was excavated and constructed by a poor weaver, Thomas Hill, and his son between 1770 and 1791. They also terraced the adjacent land and made a tea garden. The house was then finished off with battlements, and named Fort Montague in honour of the Duchess of Buccleugh, who was its principal benefactress. The son, who had sixteen children and now styled himself 'Sir Thomas Hill', flew a Union Jack from the battlements, fired salutes from a two-pounder cannon and printed his own banknotes –100,000 are estimated to have been in circulation by 1812, but only promising to pay '5 half-pence'. Sometimes also called 'The Swallow's Nest', this became 'The House in the Rock' in the 1930s. For two hundred years it was a popular tourist spot, with visitors in more recent years shown round the house by Miss Hemshall and her niece, Nancy Buckle. In 1994, it was closed by Harrogate Borough Council, partly for safety reasons, but in spite of international media interest in the campaign generated by Nancy Buckle and her supporters to keep it in the public domain, the house was put on the market by Ampleforth Abbey in 1997, and has been a private residence since 2000.

HOWELL, WILLIAM

The Revd William Howell was minister of the Congregational chapel in Gracious Street from 1778 until 1835, apart from two years as a missionary when he was twice captured at sea (see United Reformed Church). His son, Samuel, published lithographs of Knaresborough in 1836.

HOY, TOM

(See Magna Carta)

IMPROVEMENT COMMISSIONERS

Forerunners of the Knaresborough Urban District Council, they had the authority, from 1823, to undertake 'the paving, lighting, watching, cleansing and improving of Knaresborough', levying a rate of 1s 6d in the pound. They comprised the vicar, three churchwardens, the Borough Bailiff, and thirty other Commissioners. For over seventy years they lived up to their name, improving and developing the Victorian town. (See Gas Lighting)

INDUSTRY

Though Knaresborough has never been an industrial town, its economic life has included a range of industries and trades, including leather and shoemaking, the linen industry, rug-making, quarrying, lime kilns, brickworks, clock and watchmaking, timber merchants, pharmaceuticals, small enterprises manufacturing bottled sauces, lemonade and ginger beer, Baines's butterscotch and other sweets, and in recent years award-winning manufacture (e.g. GSPK) on an industrial estate, as well as a growing tourist industry. (See Calcutt, Kitching's, Linen Industry, Pickles Ointments, Ropewalk, Shoemakers)

INMAN, LORD PHILIP

Born in 1892, in a poor thatched cottage in Water Bag Bank, his was a classic rags-to-riches story. Philip's first job was as a paperboy for Parr's, then a bottle-washer and errand-boy for the Oldest Chemist's Shop. The story of his early struggle to better himself is told in his autobiography *No Going Back*. With the background of the parish church, where he was a choirboy, then encouraged by fellow Methodists, he eventually got a job in 1921 as secretary of Charing Cross Hospital, proving himself to be an enterprising and energetic fundraiser. For fifty-eight years he served as secretary, then chairman, then life president, loved by staff and patients alike. Other work included being chairman of the BBC, the Tourist Board and British Rail Catering. In 1946 he was raised to the peerage for distinguished public service, and in 1947 was created Lord Privy Seal, taking as his title Lord Inman of Knaresborough, and calling his Sussex home 'Knaresborough House'. This most honoured and accomplished of all recent Knaresborians died in 1979, aged eighty-seven. The site of his birthplace in Water Bag Bank is marked by a plaque unveiled by Lady Inman in 1981.

INNS

Knaresborough was once renowned for its extraordinary number of inns – seventy-four have been noted during the eighteenth and nineteenth centuries. These did good trade around market day and provided accommodation for spa visitors and travellers, as well as social centres for residents (see e.g. Cock-fighting). Many inns referred to in early documents no longer survive, but included, for example, the Barrel, the Elephant & Castle, the Star Inn, two called the White Horse, the Shoulder of Mutton, etc. Others have been rebuilt, such as the World's End (1898), or replaced by a modern building on the same site, such as the Ivy Cottage. Some, however, have remained almost unchanged over the centuries, in particular the Old Royal Oak, the Mother Shipton (once

called the Dropping Well), the Half Moon, the Crown, the Hart's Horn, the Marquis of Granby, the Borough Bailiff (once called the Commercial), the George & Dragon, and the Yorkshire Lass (formerly the George Hotel and the Murray Arms).

JAMES I

When King James VI of Scotland acceded to the throne of England as James I, he would have passed through Knaresborough during the Royal Progress, travelling from Ripley on his way to York. The following year, 1604, he confirmed Knaresborough's Charter, and in 1616 readily gave permission to found a school here in his name. (See King James's School)

JEWISH SYNAGOGUE

This once stood at the Kirkgate end of Jockey Lane, and the ginnel here from the Market Place is still known as 'Synagogue'. Before the massacre of Jews at York in 1190, they lived in sufficient numbers in Knaresborough to have their own place of worship. Hargrove records that a Jewish phylactery was found in the castle area in 1738 and a remnant of the medieval wall of the synagogue in 1768.

JOCKEY LANE

This narrow lane, joining High Street with Kirkgate, derives its name, according to Hargrove, from the fact that a horse dealer once had his stables here. (The earliest use of the word referred to a dealer rather than a rider.) Because there had once been a synagogue here, this had also been known as Barefoot Lane or Ten Faith Lane. (See Jewish Synagogue)

JOHN OF GAUNT

Fourth son of Edward III, so called, not because he was in any way gaunt, but because he was born to Queen Philippa (q.v.) and Edward III (q.v.) in Ghent in 1340. He was created Duke of Lancaster and became a renowned huntsman, especially in the Forest of Knaresborough, with John of Gaunt's castle, a hunting lodge, in Haverah Park. He is said to have killed the last wolf in England in about 1380. Soon becoming one of the wealthiest men in England, in 1372 he was granted the Lordship of Knaresborough. (See Lancaster, Duchy of)

JOHN THE MASON

Founder and excavator of the chapel of Our Lady of the Crag in 1408. There is a legend that he made the chapel as a votive offering following a miracle in the nearby quarry, when his young son was in danger of being killed by a falling rock, but – in his vision – was pulled out of the way by the Virgin Mary. (See Our Lady of the Crag)

JUBILEE FOUNTAIN

This was erected by public subscription to commemorate the Golden Jubilee of Queen Victoria's reign in 1887. On 31 December of that year, a procession marched down to a place just beyond High Bridge, where the first sod was cut by Basil Woodd JP, chairman of the Jubilee Committee. (The inscribed spade he used is still preserved by the Town Council.) The next year the Jubilee Fountain was supplied with sulphur water piped down the hill from a spring near Bilton Hall. Officially intended 'for the permanent benefit of the town', this spa water, drunk from a chained cup, was freely available until about 1947. The stone bowl was subsequently used as a flower-container by the owner of the Dropping Well Estate, who moved the Jubilee Fountain to private land when the estate was sold in 1986.

JUBILEE, QUEEN VICTORIA'S

Knaresborough celebrated the '50 Glorious Years' of Queen Victoria's reign in June 1887 with a week known as 'The Rejoicings', starting on Tuesday 20 June. Planned by a Jubilee Committee chaired by Basil Woodd JP, former Conservative MP for Knaresborough, the celebrations opened with 'the firing of a Royal Salute from the Russian Gun' (see Russian Gun). Then, to the ringing of church bells, there were merry processions through the streets decked with flags and banners, the whole town making for the crowded Market Place, where there were speeches, the National Anthem and 'Rule Britannia'. This was followed by a free tea for children, and a free 'meat tea' for 200 'poor people' over the age of sixty-five, and also a cricket match, concerts and a firework display in the castle grounds.

On the last day of 1887, crowds gathered to see the start of the Jubilee landscaping of the castle grounds. Basil Woodd planted the first tree amid rousing cheers, having received great acclaim for the speech in which he commented: 'What would Harrogate give to have such grand surroundings!' Led by the Volunteer Band, the police and Major Gill, the crowd then marched in procession down to the site of the Jubilee Fountain (q.v.).

KELL, JIM
The uncrowned 'Carnival King of Knaresborough', famed for his beautifully-decorated floats and tableaux, especially in the 1930s, in various street processions, galas and in the Water Carnival (q.v.). Many of his floral displays had a Christian theme, such as 'Rock of Ages', and pride of place was given to the Carnival Queen.

KING JAMES'S SCHOOL
Founded in 1616 as King James's Grammar School by the Revd Dr Robert Chaloner, Rector of Amersham and a Canon of Windsor, who was born in Goldsborough. King James granted permission in record time, no doubt pleased to have his name firmly planted in an area associated with the man who had tried to destroy him (see Fawkes, Guy). The school was for boys only, 'as well poor as rich', and still possesses the Charter, headed by a portrait of King James, and the 'Ordinances and Lawes', Chaloner's original school rules of 1616.

Discipline was strict, and the Master was to see that his boys did not come to school 'uncombed, unwashed, ragged or slovenly'. He was to 'severely punish swearing, lying, picking (pockets), stealing, fighting, quarrelling, wanton speech, uncleane behaviour and such like'. Parents had to supply 'candles for the winter' (when school started at 7 a.m.) and a bow and arrows for the games period as practice for war. There was great emphasis on grammar, both in Latin and English, on the Catechism, the Creed and the Psalms. In later years, the school motto was taken from Psalm 116: *Quid retribuam Domino?* ('What shall I give to the Lord?'). Anyone 'unapte to learne' after a year was expelled. Zero tolerance too on absenteeism: 'he shall be utterly expelled' – unless caused by illness. In the early days, school started at 6.00 a.m. in the summer, 7.00 a.m. in the winter, with an assembly in which the boys recited, on their knees, not just any old Psalm but the longest of them all: Psalm 119 (176 verses); the Creed, the Lord's Prayer and the Catechism. After year one they had to converse in Latin at all times, including playtime.

The first school was a house overlooking the parish church, given by Peter Benson, rebuilt in 1741. Under the hard-caning headmaster, H. J. Tyack Bake, King James's Grammar School moved in 1901 to a new site facing York Road. Here it was developed, from 1922, into one of the most successful grammar schools in Yorkshire by the outstanding headmaster, A. S. ('Sam') Robinson.

Under the headmastership of Frank Brewin, the school celebrated its 350th anniversary with the registering of a coat-of-arms and, in 1971, it combined with the secondary schools of Knaresborough and Boroughbridge as an 11–18

comprehensive. It was officially opened by the Duchess of Kent on 29 February 1972. Headmasters following Mr Brewin, who died tragically in 1975, were Mr J. E. W. Moreton, Mr J. R. Forster, and Dr D. Hudson. The modern uniform includes three kinds of Stuart tartan, a reminder of the failure of Guy Fawkes to kill King James.

KING JOHN

Though this Plantagenet king had such a bad reputation – partly because of hostile Church chroniclers – he was a considerable benefactor to Knaresborough. He developed and strengthened the castle (q.v.), appointing the very able administrator Brian de Lisle, and used it not only as a stronghold, but as a base for hunting deer in the Forest of Knaresborough. Sometimes accompanied by Queen Isabelle, he stayed here on seven occasions – in 1206, 1209, 1210, 1211, 1212, 1213 and 1216 – visiting Knaresborough far more than any other of the Yorkshire castles, with the exception of York and Pontefract.

The most interesting of these dates is 1210, when King John fed and clothed thirteen Knaresborough paupers during Holy Week (see Royal Maundy), and also 1216, a few months before he died, when he made a pilgrimage to the hermitage of St Robert, granting him half a carucate (40 acres) of land, on which was later built St Robert's Priory.

KIRKGATE

From the Viking for 'way to the church', the name of this steep descent to the river shows that a church existed here before Norman times. (See Knaresborough Cross, Parish Church, Water Bag Bank)

KITCHING'S

One of Knaresborough's oldest firms, this was started by David Kitching in 1877 as a timber merchant's in Boroughbridge. He moved to Knaresborough in 1898, setting up a steam-engine sawmill and a joiner's shop, the firm eventually moving in 2000 from Stockwell Road to the industrial estate; it was bought out by Travis Perkins in 2005.

KNARESBOROUGH

Origin of name. (See Angles)

KNARESBOROUGH CROSS

To see the Knaresborough Cross you have to visit St Peter's church at East Marton, as it was taken there by the Roundell family when they left Knaresborough in the eighteenth century. Although only the middle section survives, it is a good example of Viking-style carving and evidence of early Christianity in Knaresborough. (See Parish Church, Roundell family)

KNARESBOROUGH FOREST

(See Forest of Knaresborough)

KNARESBOROUGH HOSPITAL

(See Hospitals)

KNARESBOROUGH HOUSE

This fine Georgian house at the bottom of High Street, with grounds extending as far as the parish church, was built in about 1768, traditionally by John Carr. For many years, this was the home of the Collins family (q.v.). It was sold by Lady Evelyn Collins in 1951, since which time it has served as a home for the Urban District Council and the Town Council, as well as being a venue for meetings and functions. (See page 48)

KNARESBOROUGH ONLINE

knaresborough.co.uk is the locally based internet site, designed to promote local business and tourism.

KNARESBOROUGH PLAYERS

Carrying on a long tradition of amateur theatricals in Knaresborough, this company was formed in 1962, its first production being *The Happiest Days of Your Life* in Holy Trinity Church Hall. Performing also in the Community Centre, the Knaresborough Players moved to premises they transformed into the Frazer Theatre in 1965, where they have performed regularly, including the popular pantomimes. (See Frazer Theatre)

KNARESBOROUGH POST

(See Newspapers)

KNARESBOROUGH PRIORY

The Priory of St Robert of Knaresborough, never officially an abbey, was founded a few years after the Saint's death (1218) by the Trinitarian friars. Following the example of St Robert, they went round collecting alms, recognised by their white robes, which were marked by a distinctive cross of a red upright and a blue cross-bar. They divided the money into three parts: the first was for the upkeep of the priory, the second for the poor of Knaresborough and the third for paying the ransom of prisoners taken by the Saracens during the Crusades. Their rules forbade them to ride on horses (though donkeys were acceptable), or to enter taverns.

Their first known Charter was granted in 1257 by King John's youngest son, Richard, Earl of Cornwall and Lord of Knaresborough. The site of the priory was on the misnamed Abbey Road, near the river, on land roughly between the houses known as 'the Abbey' and 'the Priory', the latter having fragments of the original priory built into its garden wall and the gable end of an outbuilding. A coloured stained-glass window showing the priory gatehouse can be seen in Pannal church, founded in 1343 by John Brown, one of 'the brethren of the House of St Robert'. In 1538, the priory was suppressed on the orders of Henry VIII. It was the only branch of the Trinitarians in Yorkshire. (See Aspin Ponds, Saint Robert)

KNARESBOROUGH SPA

This was actually at Starbeck, on land which had been included in the boundary of Knaresborough by the 1778 Enclosure Act. The revival of an earlier spa here was promoted mainly through the enthusiasm of the Knaresborough chemist Michael Calvert (q.v.) and Dr Peter Murray (q.v.). A public meeting was held in Knaresborough Town Hall in March 1822, forming a trust with a hundred shares, and two months later the foundation stone of a new Pump Room was laid by the 'Masons of England' following a procession from the Elephant & Castle, High Street. By 1828, a suite of baths had been added for both warm and cold bathing. It was claimed of those who regularly drank the spa water – both sulphur and chalybeate – that 'the digestion becomes amended, the bowels and kidneys perform their functions in a more regular manner … and the skin itself gradually assumes a natural and healthy state'. Knaresborough Spa never managed to rival the well-established mineral wells of High and

Low Harrogate, with their superior accommodation, and by about 1890 it had closed down. Some of the early buildings can still be seen near the Star Beck, on Spa Lane, including the later Prince of Wales Baths (1870). The term 'Knaresborough Spa' had also been used to describe Knaresborough itself in the seventeenth century. (See Spa, Knaresborough)

KNARESBOROUGH TOWN FOOTBALL CLUB

This club started much later than the very early cricket club, but it was well-established by the early 1900s, when Major W. P. Collins was president and Frank Sturdy the chairman. In 1906, for example, the club was listed as 'Holders of the Rowntree's Challenge Shield'. By the 1920s, it was known as Knaresborough Town, with a strong team also formed by the Grammar School Old Boys, president, Councillor H. Eddy. By 1935, Knaresborough Town was prestigious enough to be seen on an Ardath cigarette card, which referred to the team having been League Champions (1933–34), York and District Division 1, and were unbeaten in that season. After the war, in 1953, the team was revived, with its home ground at Manse Lane, and by the 1970s was able to win four cups in one season. Back in the 1930s, there had been a Junior Football Club.

KNARESBOROUGH VOLUNTEERS

The best-known body of voluntary soldiers to form a militia were those led by Captain William Thornton and 'Blind Jack' during the 1745 Jacobite Rebellion (see Blind Jack, Yorkshire Blues). Though these have sometimes been called 'The Knaresborough Volunteers', the title was later officially given to a local army raised in 1794, in response to the threat following the French Revolution. On 4 July 1795, there was a gathering in Knaresborough Town Hall, where, after 'an elegant breakfast', Lady Slingsby presented the colours to Captain Robinson. The Knaresborough Volunteers were apparently not called to any action, but were mobilised on two subsequent occasions. An early town band was called the Volunteer Band. (See Jubilee, Silver Band)

KNIGHTS TEMPLAR

This military religious order, formed for the protection of pilgrims to the Holy Land, had its principal northern training ground, a kind of medieval Catterick, at Ribston Hall (q.v.). The effigy guarding the Chapel of Our Lady of the Crag (q.v.) was said to be that of a Knight Templar.

LACEY, 'GINGER'

Born in Wetherby, but educated at King James's Grammar School (1927–1933), James Harry Lacey became one of the best-known aces of the Second World War, shooting down more enemy planes in the Battle of Britain than any other pilot: twenty-eight enemy aircraft destroyed, plus five probables and nine damaged. He was awarded ten medals, including the DFM with Bar and the Croix de Guerre.

LANCASTER, DUCHY OF

In 1372, Edward III granted the castle and Honour of Knaresborough (q.v.) to his son, John of Gaunt (q.v.), who was Duke of Lancaster. Ever since then, Knaresborough Castle has been part of the Duchy of Lancaster, who still administer it as one of the royal castles. The 600th anniversary of the Duchy's first connection with Knaresborough was marked by the Castle Celebrations of 1972. (See Questor Regis)

LAWRENCE FAMILY

Noted pharmacists and proprietors of the Oldest Chemist's Shop. As father and son, William Pierpoint Lawrence and Edmund Lawrence dispensed medicine and veterinary remedies here for almost a hundred years; Edmund retired in 1965, but was active well into his nineties. William came here from London in about 1884. (See Oldest Chemist's Shop)

LELAND, JOHN

The antiquary of Henry VIII who toured England, noting places of interest, including Knaresborough, which he visited in about 1538. He noted that the 'river sides of Nidde be well wooded above Knarresburg for 2 or 3 miles, forest full of lynge (heather), moors and mosses, with stony hills'. (See also Leland's descriptions of the Castle, Market and the Dropping Well)

LEWIS, DAVID

Farmer at Belmont, who died in 1846. For a time he was a schoolmaster and accountant, and he became the first published poet to write in Yorkshire dialect. In 1815, for example, he wrote in local speech an elegy on the frog he had accidentally killed with his scythe, concluding with the thought that we must all be cut down one day by the relentless scythe of time:

Ye all mun gang
Like frogs in meadows fed bi shooers
Ere owt be lang

He also wrote lively verse in Standard English on several Knaresborough topics, including tributes to local gentry.

LIBRARIES

Knaresborough's first public library was established in about 1795, based on a yearly subscription of 10s 6d, eventually increased to a guinea. This Subscription Library was absorbed into the Literary Institution in 1843 (q.v.). Later, High Street printers and booksellers – Langdale's, Wilson's, Lowe's, and then Parr's – in turn ran their own library. In recent years, the County Library was in York Place, then in a large shop in the Market Place before moving across into a purpose-built library in 1960.

LIDO, ROGER'S

Popular name for the dam above Plumpton Mill near Grimbald Crag. Tenanted in the early 1900s by the eccentric Roger Lund, who went about barefoot, it was later run as a caravan site by the Harper family.

LILBURN, JOHN

One of Cromwell's Parliamentary officers, he was the Lieutenant Colonel responsible for the taking of Knaresborough Castle in December 1644, soon after he had taken another Royalist castle at Tickhill. Later, he became a leader of the Levellers, a group opposed to Cromwell's authoritarian style. (See Siege of Knaresborough Castle)

LILLEBURN, JOHN DE

By a curious coincidence, this man – with the same name as the officer in charge of the Parliamentarian siege in 1644 – took Knaresborough Castle in October 1317. As a supporter of the rebellious Earl of Lancaster, he held the castle until 29 January 1318, when it was recaptured by forces loyal to Edward II.

LINEN INDUSTRY

One of Knaresborough's oldest and most successful enterprises, the manufacture of linen was a cottage industry dating from at least Tudor times. Flax was at first grown locally, then imported from the Baltic via Hull – rising from 500 tons in 1717 to 2,300 tons in 1783. There are many documentary references to Knaresborough people carrying out the processes of retting, boiling, bleaching, heckling, dyeing, spinning and weaving. Writing in 1787, Hargrove says that 'Upwards of one thousand pieces of linen (20 yards by 35 inches) are manufactured in this town and neighbourhood each week'. By 1820, there were twenty-four small firms in the town manufacturing linen, as well as a dozen linen merchants and drapers. Later in the nineteenth century, the linen industry was concentrated in various mills, especially Walton's (q.v.). (See Castle Mill)

LIQUORICE

Liquorice was once grown and sold in Knaresborough, possibly having been introduced by the Trinitarian friars in medieval times. Its abundance in the fields around Knaresborough was noted by Camden towards the end of the sixteenth century. According to Hargrove, the last of the small enclosures in which liquorice was grown was one on Waterside, whose owner, Simon Warner, died in 1683. (See Dye-house)

LITERARY AND SCIENTIFIC INSTITUTION

Founded in 1843, an educational association with around 120 members, this met in the evenings to use a library of 1,500 books, hold discussions and hear lectures. In 1893 it held a Jubilee Celebration in the Oddfellows Hall, with a concert of songs and sketches.

LONG WALK

A term given to the riverside avenue, with its fine views of the town, which leads from High Bridge to the Dropping Well. This was much used in the days when 'Knaresborough Spa' still referred to the town itself, and later when Harrogate had taken over as *the* spa and visitors came to Knaresborough for recreation as part of 'the cure'. Daniel Defoe records walking along here in 1717. The Long Walk was later landscaped by Sir Henry Slingsby in about 1739. (See Spa, Knaresborough)

LORD KNARESBOROUGH

When Sir Henry Meysey-Thompson of Kirby Hall was elevated to the peerage in 1906, he announced that he would take as his title 'Lord Knaresborough'. This was partly because he had been elected an MP for Knaresborough in 1880; however, in fact, he had been unseated following a Conservative petition alleging bribery by the Liberals. There was an immediate outcry from the people of Knaresborough, with the chairman of the KUDC appealing (in vain) to Sir Henry not to use this title, as he had no family connection with the town ... This, of course, did not apply to Lord Inman of Knaresborough, whose family had for centuries been well-known Knaresborians. (See Inman, Lord Philip)

LOW BRIDGE

For many centuries, before the development of Harrogate, this bridge across the Nidd at the bottom of Briggate was the main way into Knaresborough. Originally there was a ford here, and then the river was crossed by the Staynbrig (Stone Bridge), also called March Bridge (from an old word for boundary). It is not known when Low Bridge was first built, but there are records of repairs in 1642 and enlargement in 1779.

MACKINTOSH, SIR HAROLD

The famous toffee magnate from Halifax lived in Conyngham Hall from 1924 to 1942, breeding prize dairy cattle in the extensive grounds. He presented to the people of Knaresborough a small wooded area in nearby Bilton Fields, nicknamed 'Toffee Park'.

MAGNA CARTA

Folk rock group formed in 1969. Their guitarist and vocalist, Tom Hoy, lives in Knaresborough. Before joining Magna Carta, Tom Hoy was with the Natural Acoustic Band. His latest tour to date was South Africa in 2009.

MALAM, JOHN

(See Gas Lighting)

MANOR COTTAGE

Situated at the bottom of Water Bag Bank, this Tudor building is one of the oldest and quaintest houses in Knaresborough, and the only one to retain its thatched roof. It derives its name from being within the Manor of Beechill, and was, from 1731 to 1863, owned by the Roundell family (q.v.). (See Beechill, Manor of, Old Manor House)

MARCH BRIDGE

(See Low Bridge)

MARIGOLD

Name of the houseboat which in late Victorian and Edwardian times was moored between Sturdy's boat-landing and Castle Mill. Owned for most of its life by the O'Reilly sisters, who also ran the Moat Café, it housed a stylish restaurant, serving food on the upper deck. Sometimes the *Marigold* sailed on the river, especially during the Water Carnival. Due to gradual deterioration, it sank during the early 1920s. The riverside Marigold Café preserves the old name. (See Water Carnival)

MARKET

Although the first documentary reference to a market in Knaresborough is in 1206, in the reign of King John, it must have been held since at least Norman times, when the Market Place stretched as far as the castle, whose garrison it would supply with food and goods. By 1310, the Charter of Edward II had confirmed Wednesday as market day. In Tudor times, Leland (q.v.), visiting Knaresborough, noted that 'the market there is quick' (lively). Once known for its locally-grown liquorice, then cherries, Knaresborough market was eventually selling more corn each week than any other market in Yorkshire, according to Hargrove (1809).

Over the years there have been many rules enforcing standards in weights, measures and quality, with some of the more recent regulations still on display. In 1896, for example, the KUDC approved tolls of one penny for every basket of produce brought in weighing between 14 and 28 pounds, one penny for every basket or crate of fowls, three pence for every two-wheeled cart and four pence for every four-wheeled wagon load. In the early twentieth century the market was known for its characters, such as the Morrisons, who juggled with dishes, plates and chamber pots, occasionally letting them slip and smash

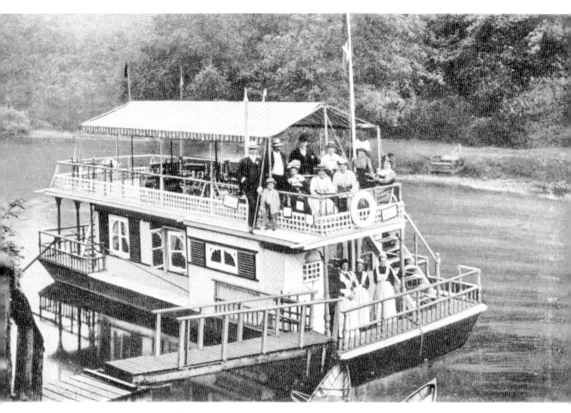

Marigold with guests and staff on the Nidd in 1912.

to draw the crowds. There was Jim Plummer the fishmonger, Frank Smith the 'Corn King', and a dentist who pulled teeth in public, as depicted in the painting by J. B. Fountain (q.v.). (See Cattle Market) A Farmers' Market has been taking place every fourth Sunday since 2010, and 2011 saw the first Easter Fair here.

MARKET CROSS
Few towns can have a Market Cross with as unusual a history as Knaresborough's. The circular stone base dates from 1709, when a new cross was erected. This was replaced in 1824, when the enthusiastic gas engineer John Malam donated a gas lamp, which can be seen in the earliest photographs (see Gas Lighting). When electricity arrived, this was replaced by a bulky transformer and a tall stand, with lamps on three branches.

Something more worthy of the fine Market Place was needed, and to celebrate the Queen's Coronation in 1953 it was decided to reinstate a Market Cross. Even this was unusual, however. Designed by L. H. Clark, the

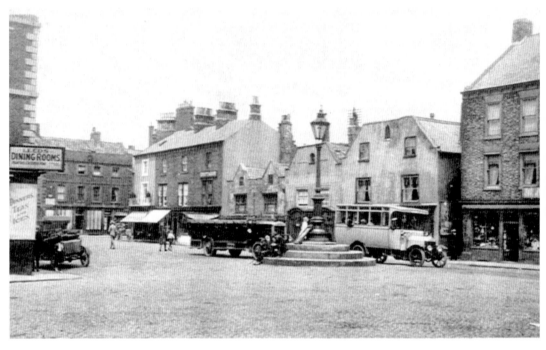

The Market Place as a bus terminus around 1910, with the gas-lamp taking centre stage.

Harrogate architect, it was a cross in a circle, said to be in fourteenth-century style. Sculpted by the Knaresborough monumental mason Cecil Naden, it was dedicated by the vicar, the Revd R. A. Talbot, on Coronation Day, 21 June 1953, and unveiled by Mr Richard Simpson, a ninety-four-year-old Knaresborian.

MARKET PLACE

Because this once extended as far as the castle, the oldest buildings are on the High Street side, and the comparatively recent ones on the south side, one of the earliest of which has a rainwater head inscribed 1741. Nothing remains to show the location of the bull-ring once known to have been here. The stocks, which once displayed malefactors, can be seen in the Courthouse Museum. The most interesting of the attractive buildings are the Oldest Chemist's Shop (q.v.) and the Old Town Hall (q.v.). From the balcony of the latter, speeches were made in the parliamentary elections (q.v.). The Market Place has been the venue for all kinds of gatherings, as well as the striking of bargains and the hiring of servants (see Statutes). The whole Market Place was once entirely surfaced in cobbles, replaced by tarmac in 1963. It was partly pedestrianised in 2002, a token few cobbles retained round the base of the Market Cross (q.v.).

MARSHALL SUITS

In 1823, Charles Marshall left £500 to provide children at the Church of England Castle Boys' School and Castle Girls' School with 'complete suits of clothing, at Easter, for two boys and two girls, being the best scholars'. This annual prize is still awarded at Knaresborough Castle School, now as an equivalent in money. (See Stevens Bibles)

MEDIEVAL DAY

The annual Medieval Day transports us back to life in Knaresborough during the Middle Ages. Events at the castle and museum include the jolly jester; the storyteller; birds of prey; wandering musicians and dancers; making shields and banners in the arts and crafts area; the medieval artist; medieval feasting and cookery; medieval tattoos; and medieval games.

METCALF, JOHN

(See Blind Jack)

METHODISTS

The most numerous denomination in Knaresborough after the Anglicans. Originally a nickname for a group of Christian students at Oxford, led by John and Charles Wesley, Methodists first met in Knaresborough in 1742, following the first visit of John Wesley. Their first meeting-house was at Bond End, then in Castlegate. The first chapel was built in 1815, and an adjacent Wesleyan Methodist chapel was built in Gracious Street in 1868, to a design by John Child, the centre of a large country circuit of chapels served by ministers and local preachers from Knaresborough. Though the 1815 chapel remains, the 1868 building was replaced by the modern Methodist church in 1975. Other Methodist chapels were the Primitive Methodist chapel off Briggate (1854) – later the Town Mission – replaced in 1901 by one at the bottom of High Street (Sid Horner, the printer's, from about 1953), and the Park Grove Methodist church, opened in 1904, where Philip Inman became a member.

Methodists were (and still are) renowned for their fervent singing of hymns, and for being active, not only in evangelism, but in social and educational work, the 1815 building in Gracious Street becoming an important Knaresborough school. (See Holden, Isaac, Inman, Philip, Sabbath and Day School, Waterloo Chapel, Wesley, John)

MOAT GARDENS
Opened in 1931, complete with paddling pool, adjacent to the castle moat, they were later renamed Bebra Gardens. (See Town Twinning)

MONOCULUS, JOHN
His Latin nickname means 'one eye', presumably because he had lost the other in battle. One of the first Lords of Knaresborough, he was the brother of Serlo de Burgh, founder of the castle, and married to Magdalen, an aunt of King Stephen. His son was Eustace Fitz-John (q.v.).

MORVILLE, HUGH DE
Leader of the four knights who assassinated Thomas Becket on 29 December 1170. The four fled and took refuge in Knaresborough Castle, where de Morville was Constable and where he had done building work. There is a tradition that as part of his penance for the murder in Canterbury Cathedral, he built the church at Hampsthwaite, significantly dedicated to Saint Thomas Becket (canonised in 1172). (See Castle)

MOTHER SHIPTON
Born in 1488 (so predating Nostradamus by fifteen years) in a cave next to the River Nidd, the legendary Mother Shipton (née Ursula Southeil) is synonymous with Knaresborough, and with the art of prophecy. Afflicted by what was probably scoliosis and variously branded a witch and the devil's daughter, her predictions have included the demise of Cardinal Wolsey, the Gunpowder Plot, the Great Fire of London, her own death, and, as yet unsuccessfully, the end of the world (1881 and 1991). The first account of her did not appear until 1641. This describes how, when living in York, she had predicted that the disgraced Cardinal Wolsey, who planned to be enthroned as Archbishop in 1530, would see York, but never reach the city. Wolsey got as far as Cawood Castle, and from the tower saw York Minster in the distance, vowing he would have Mother Shipton burnt as a witch. But he was arrested on a charge of high treason, and died on the journey south. This first printed version of the prophecies spread the fame of Mother Shipton throughout England.

In 1667, a fictionalised account of her by Richard Head stated she had been born (after her mother had been seduced by the Devil in disguise) at Knaresborough, 'near the Dropping Well'. Head's publication contains the first of many fabricated prophecies attributed to Mother Shipton, all written after

the events (e.g. the defeat of the Spanish Armada). Forgeries were taken a stage further by the Brighton bookseller Charles Hindley, who in 1873 confessed that he had made up prophecies about modern inventions and one that had caused much alarm:

Then the world to an end shall come
In eighteen hundred and eighty one

William Grainge noted that in 1848, when the viaduct collapsed, locals had started saying that Mother Shipton had always predicted that 't' big brig across t' Nidd should tummle doon twice, an' stand fer ivver when built a third time' – a garbled version of which still survives, linked with the end of the world.

Until about 1908, a cottage near Low Bridge was being visited as the birthplace of Mother Shipton. The cave near the Dropping Well, though associated with her from Victorian times, was not publicised as the actual birthplace till about 1918. Outside Knaresborough the prophetess became a figure of folklore. For two hundred years or so, she was familiar as a puppet who smoked a real pipe. A moth has been named after her: *callistege mi*, which apparently bears a profile of a hag's head on each wing. She became a popular character in pantomime, her part played by men, including David Garrick in 1759, making her the first real pantomime dame. By 1770, at Covent Garden, Mother Shipton's spectacular transformation scenes also made her the first fairy godmother.

Despite claims by numerous other towns in the UK, this is where we like to think Mother Shipton was born – to Agatha during a violent thunderstorm. The Shiptons continue to fascinate to this day, with the comparatively neglected Tobias Shipton celebrated by Middlesbrough poet Bob Beagrie in his 2010 poem, *The Seer Sung Husband*. (See Dropping Well, Long Walk, Viaduct)

MURRAY, DR PETER

One of Knaresborough's early doctors, he came here in 1803 and set up the town's first Free Dispensary, at the top of Castle Ings. Described as 'a constant friend of the poor', he retired because of his own ill-health to Scarborough in 1826, being presented with a silver tea-tray inscribed 'to Peter Murray M.D. by the inhabitants of the town and vicinity of Knaresborough … As a memorial of his benevolent virtues and professional services.' (See Dispensary)

MOTHER SHIPTON'S PROPHECY

" Near the Petrifying Well, I first saw light as records tell."

Born at Knaresborough, in the Year 1488.
Died 1561, near Shipton, York.

Over a wild and stormy sea
Shall a noble* sail
Who to find will not fail
A new and fair countree ;
From whence he shall bring
A herb † and a root ‡
That all men shall suit,
And please both the ploughman
 and king ;
And let them take no more than
 measure,
Both shall have the even pleasure,
In the belly and the brain.
Carriages without horses shall go,
And accidents fill the world with woe.
Primrose Hill in London shall be
And in its centre a Bishop's see,
Around the world thoughts shall fly
In the twinkling of an eye.
Waters shall yet more wonders do,
How strange, yet shall be true.
The world upside down shall be,
And gold found at the root of a tree.
Through hills men shall ride
And no horse or ass be by their side.
Under water men shall walk,
Shall ride, shall sleep. and talk ;
In the air men shall be seen,
In white, and black, and in green.
A great man shall come and go—
Three times shall lovely France
Be led to play a bloody dance ;
Before her people shall be free
Three tyrant Rulers shall she see,
Three times the people's hope is gone,
Three Rulers in succession see,
Each springing from different dynasty.
Then shall the worser fight be done,
England and France shall be as one.

The British Olive next shall twine
In marriage with the German vine.
Men shall walk over rivers and
 under rivers.
Iron in the water shall float
As easy as a wooden boat;
Gold shall be found, and found
In a land that's not now known.
Fire and water shall more wonders do
England shall at last admit a Jew ;
The Jew that was held in scorn
Shall of a Christian be born and born.
A house of glass shall come to pass
In England ; but alas !
War will follow with the work,
In the land of the Pagan and Turk,
And State and State in fierce strife,
Will seek each other's life.
But when the north shall divide
 the South
An eagle shall build in the lion's
 mouth.
Taxes for blood and for war,
Will come to every door,
All England's sons that plough the
 land,
Shall be seen, book in hand :
Learning shall so ebb and flow,
The poor shall most learning know.
Waters shall flow where corn shall
 grow,
Corn shall grow where waters doth
 flow.
Houses shall appear in the vales
 below
And covered by hail and snow ;
The world then to an end shall come
In Eighteen Hundred and Eighty One.

* Sir Walter Raleigh. † Tobacco. ‡ Potato.

Mother Shipton's prophecy.

MUSEUM
(See Old Courthouse)

NANNY GOAT HOLE
Shelter on the way down the crag, where goats once grazed, below the castle. It was used to house a searchlight during the Water Carnival, and was well-known to courting couples.

NATIONAL SCHOOLS
(See Castle Schools)

NEVILLE, ROBERT DE
Vicar of Knaresborough in 1349, at the time of the Black Death. After ministering to his infected parishioners he died of plague himself the following year, and was replaced by Jollan de Neville, possibly his brother, who was a farmer and served as vicar until 1354.

NEWSPAPERS
In the eighteenth century, the news from Knaresborough was carried in such papers as the *York Courant* and the *Leeds Intelligencer* (from 1754). By the nineteenth century, the town was printing its own newspaper, cover price one penny: *The Northern Luminary and Knaresborough Independent Press*, which claimed a greater circulation than any in the district, including Harrogate's papers. The *Knaresborough Post* was first published in 1863, and in the early 1900s there was the *Knaresborough Guardian*.

NIDD
This river name takes us back to the Ancient Britons. It has been suggested that Nidd is derived from a Celtic word meaning 'bright' or 'shining'. Eugene Aram's thesis (1759) was that it is from a word meaning 'below' or 'covered', because it disappears underground in Upper Nidderdale and is a name related to words like 'nether', and to other rivers (e.g. Welsh *Nedd* and *Neder*) which are partly underground.

The Nidd has always been essential to Knaresborough's economy – a means of transport, a source of fish, power for the water-wheels of various mills

Swimming and paddling in the Nidd.

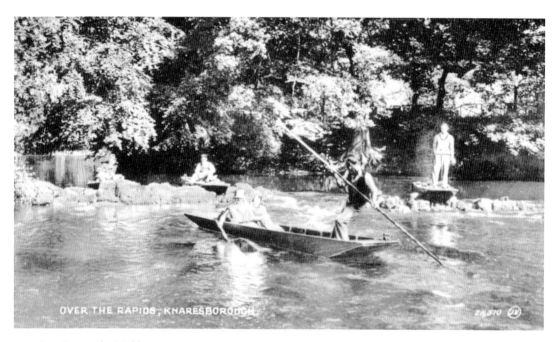

Punting on the Nidd.

for corn-grinding, fulling, textile manufacture etc., as well as boating. The Nidd also supplemented the wells of the town by supplying drinking-water, though sewage was, until Victorian times, dumped in the river. The Nidd has frozen over several times, including 1916, 1929, 1940, 1943 and 1947, with photographic evidence depicting confident sliding and skating. Many have drowned in the Nidd, especially in the notorious stretch of Cherry Tree Deep. (See Boating, Water Supply)

NIDD, SYNOD OF

This important Church assembly took place, according to St Bede, in AD 705 and was held '*juxta fluvium Nidd*' (near the River Nidd), so this could well have been in or close to Knaresborough, which had a pre-Norman church. This synod decided to allow Saint Wilfrid to return from exile.

NIGHT SOIL

A familiar term in the days before water closets replaced earth privies. The stinking content was removed after dark by the valiant 'night-soil men', who as recently as 1902 removed a total of 1,760 tons of night-soil from the outdoor toilets of Knaresborough.

NORMANS

After 1066, the victorious Norman barons, including Serlo de Burgh, were allocated various manors. The castle de Burgh started to build in his manor of Knaresborough would have served as a base when the Normans ferociously put down all opposition in the Harrying of the North (1070), reputedly not leaving a single village standing between York and Durham. As well as the castle (q.v.), the Normans started building the parish church (q.v.), where some of their architecture still survives, and which was in 1114 owned by Henry I, youngest son of William the Conqueror.

The Normans also introduced French, which was spoken here by the military, the clergy and officials for another three centuries (Edward III spoke in English at the opening of Parliament, first in 1362). Two principal Norman characteristics were efficient administration and a love of hunting. (See Domesday Book, Forest of Knaresborough, Fitz-John, Monoculus, John, Serlo de Burgh)

ODDFELLOWS

Friendly Society, whose Knaresborough Lodge was founded in 1820 and which eventually had over 400 members. In 1872, they built the red-brick Oddfellows Hall in Park Place, opened by Dr T. M. Beaumont, the medical officer of the Lodge. (See Roxy Cinema)

OLD COURTHOUSE

The only one of the castle buildings to remain intact, this has a lower part built in the fourteenth century, with the upper part added by Sir Henry Slingsby between 1590 and 1600. Here was the Court of the Honour of Knaresborough (q.v.), dealing with cases not tried by the Borough Courthouse (see Sessions House). The original courtroom has been preserved, with figures reconstructing an actual case (from 1602). This exhibit is part of the Courthouse Museum, opened in 1977, with information on the Honour supplied by Mrs Mary Mann, on the castle by John Symington and on local characters by Arnold Kellett. Since then many items have been added, making this a small treasure-house of Knaresborough history.

OLD ENGLISH LAVENDER WATER

This was originally made to a secret recipe by the Lawrence family, who sold it for many years in their Oldest Chemist's Shop. One of the most popular Knaresborough souvenirs was the old-style bottle of lavender water, 'mellowed by age and of rare and subtle fragrance', encased in wicker and bearing a red seal stamped with the date of the shop's origin, 1720. (See Lawrence family, Oldest Chemist's Shop)

OLD MANOR HOUSE

A riverside house of charm and character, deriving its name from the old Manor of Beechill, though it stands just outside this, and according to W. A. Atkinson (q.v.) it was not the actual Beechill Manor House, which stood opposite the parish church. It is of great age, being built round an ancient roof-tree, now concealed in a cupboard, and with a chequered exterior, shown in the early pictures, which may have influenced other black-and-white features in the town. Two stories about the Old Manor House have no historical support. First, that it was supposed to be a hunting-lodge used by King John. Second, it is thought 'Cromwell slept here' and – according to the novelist Halliwell Sutcliffe – even signed a treaty here with Charles I! W. A. Atkinson rightly

argued that the Cromwell story came from the fact that the bed in which he slept (at the house in High Street) was moved here and placed in the beautifully panelled Cromwell Room. From the seventeenth century, the Old Manor House was owned by the Roundell family for nearly 400 years. In living memory it was popular as a riverside restaurant, but is now a residence.

OLD ROYAL OAK

In the Market Place, the inn dates back to the eighteenth century and has its own Priest Hole.

OLD TANNERY

Dating from at least the eighteenth century, this building in York Place was traditionally first used as a tannery, part of Knaresborough's longstanding trade in leather and shoemaking. It then became a small linen mill, and was familiar in the 1950s as Clapham's Garage. In 1984, it was converted into flats.

OLD TOWN HALL

Though earlier town halls in the Market Place are referred to in documents, this dates from 1862, when it was built on the site of the old Sessions House to a design by John Child. The foundation stone was laid by Sir Charles Slingsby, who had given the site at a nominal rent, and contributed £300 towards the total cost of about £2,000. With its clock and balcony, the Old Town Hall enhances the Market Place and has served the town well for public meetings, entertainment and catering, now with the thoroughfare of castle courtyard. (See Carol Service, Parliamentary Elections, Sessions House, Town Hall Café)

OLDEST CHEMIST'S SHOP

A pharmacy at least from as early as 1720, when John Beckwith was the apothecary. The inventory of an earlier Knaresborough apothecary, Ralph Metcalfe, shows that in 1689 he stocked as many as 280 different herbs, oils, unguents and chemical powders for his medicines and remedies. Until 2003, the shop retained many of the original features, including box-windows on legs of 'Chinese Chippendale' (added about 1760), an oak-beamed ceiling, old drawers and coloured bottles, a bleeding couch, leech jar, huge pestle and mortar (turned by a dog), pill-making machine, and a small rack which once held quills of quicksilver, worn to keep both diseases and witches away; all were once proudly

displayed by the best-known chemists, Mr W. P. Lawrence and his son Edmund, who sold everything from corn cures to sheep dip. The Oldest Chemist's Shop ceased to trade as a pharmacy in 1997. (See Lawrence family)

O'REILLY SISTERS
(See Marigold)

OUR LADY OF THE CRAG, CHAPEL OF
This is the correct name for what was for many years mistakenly called 'St Robert's Chapel', perhaps because it was confused with St Robert's Cave, also in the rock face, though nearly a mile further down the river. The Chapel of Our Lady of the Crag was cut out of the crag near Low Bridge by John the Mason in 1408, and is said to be the third oldest wayside shrine in Britain. At 10 feet 6 inches long, 9 feet wide and 7 feet 6 inches high, this was 'elegantly hollowed out of the solid rock: its roof and altar beautifully adorned with Gothic ornaments' (according to an 1880s official guide to Knaresborough). The entrance is guarded by the figure of a knight holding a sword, described by early visitors in the eighteenth century as eroded, as is the nineteenth-century restoration. The knight is caught 'in the act of drawing his sword to defend the place from the violence of rude intruders'. Wordsworth visited in 1802, alluding to it in his *Effusion*. Some, including Wordsworth, took this soldier to be one of the Knights Templar (q.v.). Now officially recognised as a chapel by the Vatican, the 1890 second edition of the guide referred to above goes on to describe the interior: 'Behind the altar is a large niche, where formerly stood an image; and on one side of it a place for the holy water basin. Here also are the figures of three heads designed ... for an emblematical allusion to the order of monks (Sanctae Trinitatis) at the once neighbouring priory, by some of whom they were probably cut.' A later image of the Madonna and Child dated from 1916, when the shrine was restored by John Martin. He gave it to Ampleforth Abbey, on whose behalf it is now looked after by the parish of St Mary's, Knaresborough. The current statue was carved by Ian Judd and dedicated in 2000. The chapel is too tiny for a congregation, but mass is occasionally said in front of it. (See Catholics, John the Mason)

PAGEANT
Pageants unfolding the history of Knaresborough, written and presented by Arnold Kellett, include the Historical Pageant of 1972 and the Millennium Pageant of 2000, both using Knaresborough Castle as stage and backdrop.

Ranging from Ancient Britons to contemporary schoolchildren, the pageants brought to life, in music, dance, drama and interviews, many of the colourful characters and incidents referred to in this book.

PARISH CHURCH

The jewel in the crown of historic Knaresborough, and the most complete of its ancient buildings, showing successive stages of architecture. A pre-Norman church existed on this site (see Kirkgate, Knaresborough Cross), but the first documentary reference is to Henry I granting 'the church at Cnaresburg' to the canons of Nostell Priory in 1114. Remnants of the small Norman church can be seen in the east end, and especially in the chevron carving of the string-course. From about 1175 an extension was made in the Transitional style, with high roofs (whose high mouldings can be seen on the tower), and then a final extension was undertaken in early English style under Alexander de Dorset, the vicar appointed by King John. In this period, chapels were dedicated to Mary Magdalen and John the Baptist, the latter becoming the name of the parish church, originally dedicated to St Mary.

After the Scots raided and burnt the town in 1318, the church was eventually restored and re-consecrated in 1343, at the time of Queen Philippa, in the Decorated style, seen especially in St Edmund's chapel. There then followed, in about 1450, the Perpendicular style of the nave. The Tudor font had a heavy cover, locked to prevent the holy water being stolen by witches – later replaced by the huge late Jacobean cover. In about 1520, the distinctive little candle-snuffer spire was added to the tower.

In the Reformation, all images and statues were removed, including the rood screen, and the Bible in English and the Prayer Book became central. Fine effigies, however, appeared on the tombs (from 1600) in the Slingsby chapel. During the Civil War, the Parliamentarian troops are said to have kept their wounded and stabled their horses in there. The longest-serving vicar, the Revd Thomas Collins (incumbent from 1735) installed a new peal of eight bells in 1774 and the first known organ, just before he died, in 1788.

When Knaresborough became big enough for an additional parish, and Holy Trinity was consecrated in 1856, St John's started to remove its galleries and eventually replaced its old box pews with the present oak pews. By 1872, the Victorian restoration had raised the chancel roof to its original height, added clerestory windows to the nave, rebuilt the organ and renewed or installed stained glass, including two fine Morris windows. On Easter Monday, 1884, the vicar, the Revd Benjamin Crosthwaite, set in motion the clock in the tower, with its wise superscription 'Redeeming the Time' (from St Paul's epistles).

In 1973, exactly a century after the Victorian restoration, the churchyard was reordered and landscaped, and most of the crowded gravestones were destroyed. In 1977, the interior was refurbished, with the pulpit removed, and the provision of a moveable nave altar and an area for music and drama, so that the contemporary parish church continues as the town's oldest place of worship, and also the venue for civic gatherings and concerts. (See also Almsgiving, Parish Registers, Royal Maundy, Slingsby family)

PARISH REGISTER

Started in 1561, its first year showing forty-one baptisms, twelve marriages and twenty-one burials, the Parish Register is a most valuable historical record. A number of pages from around the time of the Civil War are defaced and the entries, presumably of Royalists, are obliterated in black. Intrigued by the old tradition that this was done by the Parliamentarians who besieged the castle in 1644 – using the blood of their wounded soldiers – these pages have been scientifically examined, but no trace of blood was found. It seems likely that attempts had been made to revive faded writing, and that the solution used darkened with age.

PARLIAMENTARY ELECTIONS

Knaresborough had the right to return two members to Parliament from the days of Mary Tudor in 1553 until 1867, when the Reform Bill reduced the number to one. The first two MPs were Reginald Beisley and Ralph Scrope, returned by a very small electorate, as voting rights in the early days were only held by owners of burgage houses. Even by 1867, the number of voters had only risen to about 270.

Small though these numbers were, the elections were often hotly contested. Voters were bribed by drink and dinners, fights broke out, and the results were bitterly disputed. The two rival factions in the Civil War were represented by a succession of MPs in several Parliaments – a Slingsby for the Royalists and a Stockdale for the Parliamentarians. Rivalries continued to flare up. In the aborted elections of 1804, for example, a Knaresborough mob insulted and pelted the landowner, Sir John Ingilby, took staves from the constables and dragged one down to the river, threatening to drown him. Rather more peaceful scenes in the Market Place centred round election speeches from the balcony of the Old Town Hall (q.v.). In 1865, for example, Isaac Holden, the Liberal textile magnate and Methodist philanthropist, beat the Conservative, Tom Collins – though the poll was topped by the popular Conservative, Basil Woodd, who was elected five times.

In 1885, Knaresborough was disfranchised – lost its right to elect an MP – as its population was below the required 15,000. During its existence as an electoral borough, it had returned 187 members to the Commons. In 1997, Knaresborough recovered its right to an MP with the creation of the new constituency of Harrogate and Knaresborough, the first member to be elected being Phil Willis, Liberal Democrat. (See Holden, Sir Isaac, Woodd, Basil Thomas)

PARR'S STATIONERS

Taking over from A. W. Lowe at the end of the nineteenth century, William Parr's shop at the entrance to the Market Place became Knaresborough's essential stationer, bookseller and printer, especially of *Parr's Knaresborough Almanack* and various brochures and booklets on the town. By the 1920s, Parr's was selling not only books and magazines, but had a small library and a showroom for toys, fancy goods, fountain pens and the new novelty, wireless (see Almanack). The bookselling function is now carried out by the Knaresborough Bookshop, which has been in business on High Street for over forty years.

PENNY CLUB

Founded in 1808, this charity provided the poor of Knaresborough with blankets, subscribers paying one penny per week. By 1831, the number of persons given free blankets was 6,435. Later it became known as the Blanket Club, and was in operation until the First World War. There was, in addition, a Clothing Club in the early 1900s, when the vicar, the Revd W. E. Hancock, was chairman.

PENNY FERRY

To save visitors on Waterside a long walk round to get to the Dropping Well, young George W. Smith, boatman with Sturdy's before the First World War, started his popular 'Penny Ferry', rowing a boatload of up to half a dozen visitors across the river at a penny each. (See Boating, Water Carnival)

PETRIFYING WELL

(See Dropping Well)

PICKLES OINTMENTS

Pharmaceutical firm brought to Knaresborough in 1967 by Stanley Horner. In 1994, Pickles bought the Oldest Chemist's Shop, whose tradition of making ointments fitted well with its own successful products, such as 'Snowfire' and 'Fiery Jack'.

PILGRIMAGE OF GRACE

Protest movement by northern Catholics against Henry VIII's treatment of monks and monasteries, with a popular uprising in 1536. The following year, Henry VIII, going back on his promises, ordered the execution of 200 Catholics who had taken part, including Lord Darcy, Steward of the Honour of Knaresborough, and Sir Thomas Percy, Lord of Spofforth.

PLANTAGENET

Royal line, named after their emblem, a sprig of broom (*genista*), from Henry II to Richard III. In Knaresborough, the best known was King John and his youngest son, Richard Plantagenet, who, followed by his son Edmund (died 1300), was Lord of Knaresborough.

PLOUGH SUNDAY

Traditionally the first Sunday after Epiphany, and the day before Plough Monday, when sword-dancers celebrated the start of the new season in the fields by taking round a plough and collecting money, usually accompanied by the drinking and lively antics of the 'Plough Stots' (bullocks). The custom was revived in Knaresborough in 1983 by the Claro Sword and Morris Men. After the service in which the rector blesses the plough, sword dances are performed, and the mock horse, Dobbin, pulls the plough up into the Market Place. (See Sword Dance)

PLUMPTON FAMILY

Lords of the Manor of Plumpton who had a long association with Knaresborough. Sir William Plumpton, whose son had been killed at the bloody Battle of Towton in the War of the Roses (1461), was Constable, Seneschal and Master Forester. He lived at Wintringham Hall, having had a clandestine marriage in 1451 to Joan Wintringham, and in 1472 had to defend himself in court against 'unlawful intimacy, to the great peril of his soul and the grievous

scandal of all the faithful'. As the family became its patrons, St Edmund's chapel in the parish church was known as the Plumpton Chapel until the seventeenth century. (See Wintringham Hall)

PLUMPTON ROCKS

This beautiful area of lake and rocks, covering some 20 acres, was for centuries associated with the Plumpton family. After the death of John Plumpton, the last of the line, in 1749, the estate was sold to Daniel Lascelles for £28,000. Before moving to Goldsborough Hall, he had the area landscaped, and it remains today as an outstanding example of an eighteenth-century pleasure-ground. The prehistoric Devil's Arrows near Boroughbridge are thought to be made of rock from Plumpton.

POPULATION

For most of its early history the population of Knaresborough was small, numbering hundreds and eventually a few thousand, reaching 4,006 by 1821. In this last year, the population of High Harrogate by comparison was 1,583 and Low Harrogate 1,010. By the end of the century, however, Harrogate had grown into a town of about 30,000, whereas Knaresborough remained static. By 1911, it had a population of only 5,315, which by 1931 had risen to 5,942. After the Second World War, the numbers rapidly increased, rising from 8,950 in 1950 to around 14,000 in 1990. The houses built for commuters and retirees accounted for much of this increase.

POSTAL SERVICES

Names of a few of Knaresborough's early postmasters have come down to us – Stephen Parr, for example, a schoolmaster and trustee of the 1815 Methodist chapel, and Mrs Henrietta Parr, said to have been Britain's first postmistress. The first known post office was the building at the top of Kirkgate which later became a pork butcher's (Zisler's, then Holch's, now Robinson's). By late Victorian times, there was an efficient office in Knaresborough, run by postmaster Charles Blenkhorn, the boatman and landlord of the World's End. He sold stamps and postal orders, issued licenses, took in savings and handled telegrams. Long-serving postmen, such as Thomas Thorpe (from 1830) and John Patrick (from 1895), could deliver letters up to three times a day, and there were three collections from the main pillar boxes in High Street and the Market Place (one on Sundays).

PRIORY
(See Knaresborough Priory)

QUAKERS
Popular name for the Society of Friends, originating when the founder, George Fox, told a judge he should 'quake and tremble before the Lord'. The Quakers were active in Knaresborough and characteristically demonstrated against formal Christianity in churches or 'steeple-houses'. In 1655, three Quakers stood up with their hats on in the middle of a sermon being preached by the vicar of Knaresborough, Revd Matthew Booth, denouncing him as a false prophet. They were arrested, and imprisoned for eight weeks. One of them was Thomas Warner, the dyer (see Dye-house). George Watkinson of Scotton, also imprisoned for creating a disturbance in Leeds parish church, held meetings in Scotton. They were visited by George Fox in 1666, who noted they had had 'a glorious time'. A few years later, in 1670, Scotton opened its little Quaker burial ground, which is still used. By 1691, when the Friends were less disruptive, the Knaresborough home of Mary Middleton was licensed for worship. In 1701, the first Quaker meeting-house was built in Gracious Street. By the following century, Quakers were less active in Knaresborough, and from 1854 they went to the new meeting-house in Harrogate.

QUARRELS
Crossbow bolts, from Latin *quadrellus* (square-shaped). Made from iron ore smelted in Knaresborough Forest, these were exported from Knaresborough Castle in great quantities during the reign of King John. As he was building up the emergent Royal Navy, it is interesting to note that in 1213, Brian de Lisle sent 3,000 quarrels to Portsmouth and 10,000 to Poole. In the previous year, 62,000 quarrels had been sent from Knaresborough Castle, costing £46 4s 8d. Then, in 1214, King John ordered as many as possible to be sent to Portsmouth, with 1,000 retained for the defence of Knaresborough. These munitions, essential for medieval crossbows, were made, or at least finished off, in the fifteen small forges from the thirteenth century found in the castle excavations of S. C. Barber (q.v.).

QUARTER SESSIONS
Presided over by a Justice of the Peace, the Quarter Sessions, meeting in the Sessions House (q.v.), dealt with various infringements of the law, and were

especially concerned with the maintenance of highways. In 1640, for example, William Broadbelt was fined £5 for not repairing the road between Plumpton and Spitalcroft. In 1642, Low Bridge was declared in 'great ruine and decay' and ordered to be repaired at a cost of £40 from the County rates. In 1648, it was reported to the Sessions by Thomas Stockdale that the road out of town from High Bridge was so bad that nobody could pass that way 'with horses, carriages or goods, without great danger', and Bilton-with-Harrogate was ordered to repair it. The Quarter Sessions also administered poor relief and generally monitored public behaviour, but were best known for their licensing of ale-houses and the fines they imposed on illegal drinking.

QUEEN PHILIPPA

Philippa of Hainault, a fifteen-year old princess, tall, beautiful and graceful, who spoke both Flemish and French, came to York to marry Edward III on 24 January 1328. The King brought his teenage bride to Knaresborough Castle for a short honeymoon, appropriately enough, as he had granted her, as part of the marriage settlement, 'the Castle, Town, Forest and Honour of Knaresborough, of the value of £533. 6s. 8d.' Queen Philippa came here again, from 1332, taking a practical interest in the administration of Knaresborough, as is shown by the frequent references to her in local documents.

Queen Philippa often travelled with her husband, and was present at the defeat of the Scots at the Battle of Neville's Cross (1346) and the capture of Calais (1347), when she pleaded for the lives of the Six Burghers, shown in Rodin's marvellous sculpture in Calais (and its replica near the Houses of Parliament). Less well-known is the fact that she successfully pleaded for the lives of the carpenters who had made a stand which collapsed at a tournament she attended in York. Though she never settled in Knaresborough, the Queen must have spent many happy times here, sometimes with Edward and their children, including the two sons who became famous as the Black Prince and John of Gaunt. A particular interest was the parish church, whose restoration and re-consecration she oversaw in 1343. She died in 1369. For many years the castle displayed 'Queen Philippa's chest'. But her lasting memorial here is the parish church.

QUESTOR REGIS

From the Latin for 'one who seeks on behalf of the King', the title was used for the receiver of the Crown rents for the Duchy of Lancaster. This explains why a seal of the Duchy, dated 1616, has the letters 'E.R.: Q.R.' underneath the

The iconic viaduct shown in Frank Brangwyn's 1924 'Over the Nidd'.

castle emblem, standing for 'Edward Rhodes, Questor Regis.' (See Lancaster, Duchy of)

RAILWAYS

At the remarkably early date of 1819 a committee was set up to produce *The Report of the Knaresborough Railway*, envisaging what would have been perhaps the earliest line in the country to transport flax, linen, timber, coal, limestone, etc., as well as passengers. As insufficient investment was available, the first railway to reach Knaresborough did not arrive until 30 October 1848. This line from York was forced to stop at a temporary station at Haya Park because the viaduct across the Nidd collapsed just before being completed in 1848. The following year, the tunnel under High Street was finished by George Wilson and his 270 workmen. After the viaduct was rebuilt in 1851, the line extended as far as Starbeck, with a line going through to Harrogate by 1863. Knaresborough station was completed in 1865, and further developed in 1890.

Knaresborough railway station.

In late Victorian and Edwardian times, and up to the Second World War, great numbers of visitors came by train to Knaresborough, advertised in attractive posters. (See Viaduct)

RAILWAY STATION
Visitors to Knaresborough have been arriving at the town's Grade II listed station since its opening in 1848 on the Harrogate line, 17 miles west of York. The signal box is very unusual, in that it was built as an annex onto an existing row of terraced houses at 53 Kirkgate.

RAVENS
Knaresborough Castle ravens came in to being as a community project for the Millennium, with the permission of HRH The Prince of Wales, in order to have captive ravens on display at the castle, which could be seen close up with better

photographic opportunities than are available at the Tower of London. Igraine Skelton is HM Keeper of the Castle Ravens for the Duchy of Lancaster.

RENAISSANCE KNARESBOROUGH

The organisation set up here in 2004 to identify, develop and deliver projects to improve the town. Recent work has included: Knaresborough Riverside improvements; Horseshoe Field Bridge restoration; improvements at Bebra Gardens; and Frazer Theatre improvements. Perhaps the most striking and attractive venture has been the 'Trompe L'Oeil' Town Windows project – paintings by local artists in windows to depict various aspects of the town's history. It began with the idea of extending the *trompe l'oeil* paintings that appear in Knaresborough town centre as part of feva (q.v.) to combine the *trompe l'oeil* style of visual trickery with the blind windows that appear on the upper floors of some of the town's Georgian buildings. Currently there are thirteen paintings on eight properties.

RIBSTON HALL

Medieval site associated with the Knights Templar (q.v.), two of whom are said to be buried in the chapel attached to the house, one on each side of the altar. From the sixteenth century, Ribston Hall was the seat of the Goodricke family (q.v.), notably Sir Henry Goodricke, Privy Counsellor to William III. The famous apple, the Ribston Pippin, from which Cox's Orange Pippin is descended grew in the grounds here from 1707.

RICHARD II

Deposed by Henry Bolingbroke, son of John of Gaunt, whose lands he had confiscated, King Richard was imprisoned in various castles, including Knaresborough in 1399, shortly before his mysterious death in Pontefract Castle. According to the chronicler Hardynge:

> And to Knaresburgh after led was he,
> But to Pountefrete last, where he did dee

The tradition is that in Knaresborough he was imprisoned, not in the dungeon, but under house-arrest in the King's Chamber.

RICHARDSON, THOMAS

Founder of the Charity School (1765), still seen at the bottom of High Street, with the inscription in stone showing the amounts given by various benefactors. The school became known as 'Richardson's', deservedly so, as he eventually gave at least £1,200 towards its upkeep. The school, unlike King James's Grammar School, taught both boys and girls, and provided many with apprenticeships. It was amalgamated with the Grammar School in 1895. (See King James's School)

ROMANS

As the Romans, following their victory over the Brigantes (see Ancient Britons), had built their great walled city of Isurium Brigantum at nearby Aldborough, it is likely that there was a Roman presence, even an outpost, in Knaresborough. Roman coins have been excavated here, the most notable find being in a vase in Tentergate; another large find of bronze vessels and smith's tools, known as the 'Knaresborough Hoard', can be seen in the Yorkshire Museum in York.

ROPEWALK

Name usually given to the ropeworks on Crag Top in late Victorian times, run by the Johnson family, who also had a shop in High Street selling 'ropes, cords, twines, halters, reins, ploughlines and clotheslines'.

ROTULUS MISAE

King John's expense account recording his gifts to Knaresborough paupers in Holy Week, 1210. (See Royal Maundy)

ROUNDELL FAMILY

Landowners in Knaresborough and Scriven, mentioned in records from the early fifteenth century onwards. They were closely associated with the parish church, where the Plumpton chapel changed its name, from the seventeenth century, to the Roundell chapel. When Danson Roundell moved to Gledstone House, East Marton, near Skipton, in about 1768, he took with him the ancient Knaresborough Cross (q.v.).

ROXY CINEMA

This was opened in the Oddfellows Hall in the early 1930s by Robert Taylorson, who had come to Knaresborough from County Durham. He installed the latest sound projectors and welcomed his patrons standing at the door in evening dress and white tie. Affectionately nicknamed 't' bug-'utch' and 't' laff an' scrat', the Roxy became a popular Knaresborough amenity, known for its Saturday matinées and double seats at the back. Later taken over by Star Cinemas, it was replaced by a bingo hall in 1962.

ROYAL MAUNDY

The first known Royal Maundy took place in Knaresborough in 1210, during a visit by King John. This fact was discovered by Arnold Kellett (who then happened to be mayor) in 1985, and was accepted by the Royal Almonry. Obscure records (mainly in *Rotulus Misae*) show that on 5 April 1210, the *Die Jovis Cene* (on the Day of the Lord's Supper), King John, staying at Knaresborough Castle, gave to thirteen poor men of Knaresborough Maundy gifts of 13 pennies each: a robe, breeches, a girdle, a knife and shoes. The figure of thirteen was a reference to the numbers of diners at the Last Supper, not to the monarch's reign or age, as in later tradition (a red purse of money is still given 'in lieu of clothing'). Following Maundy Thursday, King John observed Good Friday by providing a meal in Knaresborough for a hundred paupers (costing 9s 4½d) and a thousand more in Yorkshire (£4 13s 9d), both meals including bread and fish.

As King John had been excommunicated by Pope Innocent III the previous November, it looks as though he was asserting his right as a Christian king to associate himself with the tradition of Maundy (from Latin *mandatum*, the new commandment of Jesus to love and serve). The author staged a reconstruction of the occasion on Maundy Thursday 1987, and during the Millennium Pageant of 2000. In April 2010, the 800th anniversary celebrations of the first Maundy given by King John were held at the castle, the very first giving having taken place in Knaresborough in 1210.

RUSSIAN GUN

Originally kept in a railed enclosure in the castle grounds, near the War Memorial. This 24-pounder cannon, captured at Sebastopol, was presented to the town by Lord Panmure in 1857, soon after the end of the Crimean War. On special occasions, or for a small fee paid to Charles Coates, harmless lumps of turf were fired across the gorge. Ironically, the cannon and its railings were

taken away for salvage during the Second World War. (See Jubilee, Queen Victoria's)

SABBATH AND DAY SCHOOL

The Methodists of Gracious Street Chapel (1815) developed their Sunday School so that it was held on weekdays as well as the Sabbath, and taught children not only the Bible and Christian doctrine, but reading, writing and arithmetic. By 1842, their register shows they were teaching '70 scholars, mostly children who have no other means of instruction'. The Gracious Street School – by now called the Wesleyan School – became the biggest in the town, with 287 receiving an education there by 1878. In 1907, it was taken over by the West Riding County Council, becoming the Council School that moved down to new buildings in Stockwell Road in 1915. (See Methodists, Secondary School)

ST JOHN'S

(See Parish Church)

ST JOHN'S HOUSE

One of the oldest houses in Knaresborough, at the end of Church Lane, dating from 1498. It is a fine example of a Tudor building, with oak beams and wattled infilling.

ST MARY'S CHURCH

Having moved from their mission in Union Street, the Catholics built their church at Bond End in 1831, to a design by John Child. The foundations include stone from the ruins of St Hilda's chapel at Rudfarlington. Annexed to the church are premises for the priest, and there was also a school, which by 1851 was teaching 102 boys and 95 girls. St Mary's School was rebuilt in 1888, and in 1967 moved, as a primary school, to new premises in Tentergate Road. Always maintaining its link with the Benedictines and Ampleforth Abbey, St Mary's has kept its general outline, but the interior has been modernised. In 1961, it was badly damaged by fire, completely refurbished in 1973 and redesigned in 2001. The prominent position of St Mary's at the roadside, together with its calvary (a war memorial), makes it easily noticed by visitors. To the Catholics of Knaresborough it has the old nickname 'The Gate of Heaven', which was once written over the entrance. (See Catholics)

ST ROBERT OF KNARESBOROUGH

Knaresborough's once world-famous eccentric saint was born Robert Flower, in York, in about 1160. He came of a good family, his father and brother becoming mayors of York, but he chose to lead the life of a religious hermit, wandering about the Knaresborough district, eventually settling in the riverside cave near Grimbald Bridge which is still to be seen. Robert lived on roots and barley-bread, and drank only water. He grew his own crops and, according to legend, tamed stags and harnessed them to his plough. Latin texts in prose and verse tell his story, and also fifteenth-century verse, which includes the lines:

> To begge and brynge pore men of baile,
> That was hys purpose principale.

Because he befriended the poor and lawbreakers, he was often in conflict with the authorities (see Stuteville family). But King John made a pilgrimage to his cave in 1216, and was impressed by his piety; this was in spite of the fact that Robert, deep in prayer, had at first refused to be disturbed, and then asked the retinue to point out which one was the King. Robert died in 1218, and the priory later built on land given by King John carried on the saint's tradition of helping prisoners. His healing miracles continued to be associated with St Robert's tomb (probably confused with St Robert's Well), visited by so many, including Edward I, from Knaresborough Castle, that it was said that Robert of Knaresborough was one of three most popular saints in Europe. (See King John, Knaresborough Priory, St Robert's Well)

ST ROBERT'S CHAPEL
(See Our Lady of the Crag, Chapel of)

ST ROBERT'S WELL

Identified by Arnold Kellett in the 1960s as a spring off Manse Lane, and in 1980 it was marked at his request by BNL Ltd, who built an open well-head. On this site there used to be Bathing Well Farm, and earlier a small local spa had been based on this spring, the nearest to St Robert's Cave. (See St Robert)

SALLY PORTS
(See Underground Passages)

SANITATION

For much of its history, Knaresborough, though picturesque, was troubled by smells and insanitary practices. Even in 1764, when an Act of Parliament authorised a water-supply pumped up from the Nidd, it had to threaten to punish those who put 'any filth, rubbish, cats, carcasses or carrion' into the river, conduits, reservoirs or cisterns. A tainted water-supply, dirty streets, uncovered ditches and dunghills, and single privies shared by many families, were a persistent menace until the Improvement Commissioners started to tackle the problem of sanitation. In 1850, the first real sewage pipe was laid underneath High Street, but it was not until the early 1900s that there was a proper sewage system, with the luxury of the first water-closets. (See Cholera, Night Soil, Water Supply)

SCHOOLS

In addition to the well-established schools listed below, Knaresborough has over the years had many private schools, including various 'dame schools', the school run by Eugene Aram, Thomas Cartwright's school in Gracious Street (where Bishop Stubbs was a pupil), the school in Castle Mill, Clarendon House Academy, Miss Carrie Pullman's school and, in the 1940s, Clevedon School. *Baines's 1822 Directory* tells us that there were ten other schools in Knaresborough at the time, including Thomas Cartwright's (classical and commercial) and the aptly named Sarah Fairlass school for ladies, on the High Street. The most recent schools, apart from extensive development at King James's School, are – on their present sites – primary schools: Goldsborough (1873), Manor Infants (1949), St Mary's (1967), Aspin Park (1969), Meadowside (1970) and Castle CE (1971) – and also Forest Special School (1968). (See Castle School, King John's School, Sabbath and Day School, St Mary's, Secondary School)

SCOTCH GEORGE LANE

Name of unknown origin, but said to be derived from that of a Scottish cattle drover who regularly passed this way.

SCOTTISH RAIDS

Flushed with the victory of Robert the Bruce over Edward II at Bannockburn (1314), marauding Scots started to ravage the north of England under Black Douglas, raiding Knaresborough in 1318. They made no impression on the

castle, but plundered and burnt the town, destroying 140 out of a total of 160 houses, and partly burning the parish church. (See Vaux, William de)

SCOUTS AND GUIDES

Very soon after the launching of the Boy Scouts movement by Baden-Powell in 1907, a troop of Scouts had formed in Knaresborough, as we see from a photograph of boys in the old-style uniform in front of the thatched cottage on Water Bag Bank where Philip Inman was born. The first Knaresborough Scoutmaster was John Patrick, who had served with distinction in the Boer War and was a Knaresborough postman for thirty years. Before the Second World War, Scouts flourished at King James's Grammar School, led by Captain John Fairclough, and in Knaresborough and Scriven, along with Cubs, under William (Bill) Campbell, who served from 1952 until 1975 and was awarded the Silver Acorn in 1994. There have also been companies of Guides and Brownies here, the first starting in 1919. Then there have been Guides at King James's Grammar School, led by Doris M. Dews (1919–53), Mrs Edna Pinder and Miss Jewitt. In the town the long service of Dorothy Harrison was recognised by the award of the Silver Fish, and there was important work also from Helen Clegg and Avril Learoy. In 1985, a new headquarters, used by both Scouts and Guides, was established on Wetherby Road.

SCRIVEN

Though now part of Knaresborough, this was originally a close but separate village, officially the 'township of Scriven-with-Tentergate', and still has its own Parish Council. The distinctive nature of Scriven has been maintained by the old houses round Scriven Green, and especially by the adjacent Scriven Park, since medieval times the seat of the Slingsbys. (See Scriven Hall, Scriven Oak, Slingsby family)

SCRIVEN HALL

It is not known when the ancient Slingsby family built the first hall, but it was partly rebuilt in Elizabethan times, and took on its most familiar appearance when Sir Henry Slingsby added a new front in about 1730. This is how it appears in prints and photographs. During the Second World War, it was requisitioned by the government, used for secret operations, even visited by Winston Churchill and later used for prisoners of war. On 20 December 1952, as a result of a fire caused by workmen, it burnt down. All that survives is part

of the old stable block and the fine gates (attributed to Inigo Jones) on Ripley Road. Miss W. Jacob-Smith bequeathed a substantial acreage of Scriven Park to the people of Knaresborough, opened in 2008. (See Slingsby Family)

SCRIVEN EVERGREEN OAK

This magnificent tree of Luscombe oak was planted by Sir Charles Slingsby when he came of age in 1845. Because of disease it had to be felled in 1996, but saplings from it will provide a continuing evergreen oak on Scriven Green.

SEAMLESS SHIRT

Exhibited by the linen firm of Walton's (q.v.), this shirt, woven on a handloom in a single piece by George Hemshall, won the Prince Albert Medal at the Great Exhibition of 1851.

SECOND WORLD WAR

Between 1939 and 1945 Knaresborough, as everywhere in the country, became familiar with the blackout, air-raid precautions, fire-watching, evacuees, rationing, shortages and requisitioning – such as of Scriven Hall and Gracious Street Methodist schoolroom. Fifty-four Knaresborough service personnel were killed in action. The war came to Knaresborough in 1940, when a German plane dropped bombs in a field off Boroughbridge Road, in the grounds of Scriven Hall and in Bilton Fields. As part of the war effort, factories for making parachutes were established in Iles Lane and on Waterside, and the whole town supported Warship Week, adopting HMS *Wallflower* and raising £337 7s 12d in savings by the end of one week – a rate of £41 per head, which was the highest in all England. (See Clayton, 'Bunny'; Lacey, 'Ginger')

SECONDARY SCHOOL

Originally known as the Council School, then as the Secondary Modern School, finally Knaresborough County Secondary School, this had moved from the Gracious Street chapel into new buildings in Stockwell Road in 1915. Under headmasters such as Sam Carter, Jack Thompson and finally Arthur Lancefield, with long-serving teachers such as Miss D. A. Arnold (thirty-five years) and Arthur ('Wiggy') Prest (thirty-nine years), this gave a sound education to Knaresborough children who had not been selected for the Grammar School. In 1971, it combined with the latter, and also Boroughbridge County Secondary

School, to form a new Comprehensive. (See King James's School, Sabbath and Day School)

SEER SUNG HUSBAND
(See Mother Shipton)

SERLO DE BURGH
Norman knight who was the first Lord of Knaresborough. (See Castle, Normans)

SESSIONS HOUSE
Originally the Tollbooth, this was rebuilt in about 1768. There were two prison cells beneath which, according to John Howard, there was a rat-infested open sewer. The Sessions House was rebuilt again in 1838, ready for the Brewers' Sessions. Also used as a Town Hall, it was yet rebuilt in 1862. (See Old Town Hall, Quarter Sessions)

SHIPLEY'S
Riverside café and tea gardens opposite Sturdy's boat-landing, especially noted for its ice cream: a Mecca for visitors, mainly between 1922 and 1945.

SHOEMAKING
The trade and craft of cordwaining, the making of boots and shoes, was for centuries an important feature of Knaresborough's economy. There were sufficient cordwainers in the town to celebrate their patron saint every St Crispin's Day (25 October), and the *Directory of 1831* listed no fewer than sixteen boot and shoemakers in Knaresborough.

SIEGE OF KNARESBOROUGH CASTLE
Following their resounding victory at Marston Moor in July 1644, Cromwell's Parliamentarian forces moved towards Knaresborough, preparing to take the castle that had remained loyal to King Charles. It was not until 12 November that the first skirmish took place, the Royalists retreating into the castle, losing twenty killed, forty-eight wounded and forty-six taken prisoner. The

Parliamentarians lost twelve men, as well as prisoners. The siege began in earnest at the beginning of December, when Colonel John Lilburn and about 600 Parliamentarian soldiers surrendered the castle. The Royalists made a spirited defence, coming out into the moat through the southern sally-port and attacking the besiegers, killing or wounding forty-two and taking twenty-six prisoners. But on 20 December 1644, the Parliamentarians, firing their four cannon to the left of the Barbican Gate, made a breach in the wall, 11 feet by 6 feet, and the Royalist garrison surrendered, after being promised life and liberty. (See Castle, Lilburn, John)

SILVER BAND
Knaresborough's tradition of military music goes back to 1745, when Blind Jack was musician with the Yorkshire Blues (q.v.). A link with the later militia, the Knaresborough Volunteers of 1794, is suggested by references to the 'Volunteer Band', traditionally formed in 1879. Under this name, Knaresborough's town band gave its first open-air concert, on 30 May 1894, in the castle grounds. The connection with volunteers was further strengthened in August 1914 when the Volunteer Band led a procession of the first Knaresborough soldiers from the Market Place to the railway station. Later known as the Prize Band, Brass Band and, finally, Silver Band, players increased in number and professionalism, and in 1930 purchased a set of new instruments – eight cornets, two flugel horns, three tenor horns, two baritone horns, two euphoniums, three trombones, four tubas, a side drum and a bass drum. The conductor at the time was James Watson, and the band-room at the rear of the George and Dragon, where Monday-night practices were held for many years. Knaresborough Silver Band introduced new uniforms in 1952, and in the early 1990s. In recent years, under the conductorship of David Tankard, instruments and uniforms have again been renewed.

SLINGSBY FAMILY
This ancient and distinguished family, by far the biggest landowners in Knaresborough, first became associated with Knaresborough when William de Slingsby married Joanna, daughter of Henry de Scriven, in 1333, from which time the Slingsbys took over from the De Scrivens as Foresters of Knaresborough. From more recent centuries, the Slingsby chapel in the parish church preserves tangible evidence of the family in its remarkable tombs, with effigies and inscriptions. First, we see that of Francis Slingsby, who died in 1600 aged seventy-eight, lying next to his wife Mary, daughter of Sir Thomas Percy, the Latin inscription recording that Francis was a cavalry officer serving Henry

VIII and Mary Tudor, and Commissioner under Queen Elizabeth. The couple had three daughters and nine sons, but the eldest, Thomas, was drowned in the Nidd, aged twenty-eight, trying to rescue a servant.

The sculpture of their eldest surviving son, Sir Henry Slingsby (died 1634), is shown rising from the dead on the Day of Judgement. He became High Sheriff of Yorkshire, but was jailed for two years for mishandling the estate of the Duchy of Lancaster. Henry was an MP for Knaresborough, like his brother William, sculpted here as a Royalist officer. He had sailed as Commissary of the Fleet in the second pillaging and burning of Cadiz in 1596, and was knighted by James I in 1603.

Sir Henry Slingsby (often called 'Harry' to distinguish him from Sir Henry, his father) is commemorated by a plain slab of black marble, brought for his tomb from the ruins of St Robert's Priory. Loyal to Charles I, Sir Henry fought on the Royalist side at Marston Moor, and later met there with the Sealed Knot. He was tried for treason in 1658 and '*a tyranno Cromwellio capite mulctatus*' (beheaded by the Tyrant Cromwell), his headless body being brought here from Tower Hill. (See Scriven Hall)

SLINGSBY, SIR CHARLES

The last direct male descendant in the Slingsby line, Sir Charles of Scriven Hall was a keen huntsman, and is remembered especially for his tragic death during the York and Ainsty fox-hunt on 4 February 1869. As he was crossing the River Ure near Newby Hall, the horses in the crowded ferry-boat became restless, the boat capsized and within minutes eight horses and six men, including Sir Charles, were drowned. The funeral in and around the parish church was the largest in Knaresborough's history, with at least 1,500 mourners arriving on foot, as well as ten coaches of dignitaries and fifty-three private carriages. The sister of Sir Charles Slingsby, Emma Louise, gave in his memory the tomb in the Slingsby chapel, with its fine recumbent effigy, sculpted by Boehm, and also the West Window. (See Scriven Oak)

SLINGSBY BABY CASE

This was the popular name given to the lawsuits involving a member of the Slingsby family and his American wife claiming that an adopted child was their own, and so legally entitled to the Slingsby inheritance. They lost their case, and in 1916 the Slingsby Estate, covering much of Knaresborough, was sold off by public auction; the Dropping Well Estate, for example, was bought by J. W. Simpson.

SOCIETIES AND SPORTS CLUBS

There are at least a hundred of these in Knaresborough, a few with a long ancestry. Many have disappeared, such as the Pigeon Homing Society, the Amateur Swimming Club and Humane Society, the Band of Hope, YMCA and the Savage Club, whose members dressed up as Red Indians and fierce tribesmen. But the four Victorian angling societies may be said to survive in the Knaresborough Anglers (founded 1875) and the Piscatorials. The Knaresborough Horticultural Society (one of the oldest in the UK) can trace its roots back to exhibitions as early as 1861. In addition to cricket (q.v.), football (q.v.) and the rugby club (revived 1982) and squash club, old clubs include tennis (from Victorian times, revived in 1984), bowls (from the early 1900s, revived 1920), and the Knaresborough Golf Club (from 1920).

There are, of course, societies connected with churches and political parties, and branches of organisations such as the WI, Rotary, Inner Wheel, Lions, Countrywomen's Association, Britain in Bloom Committee, and so forth. More recent societies to enliven the community include the Youth Club (at Chain Lane from 1982), Civic Society (1961), Camera Club (1966), Historical Society (1969), Men's Forum (1970), Flower Club (1974), Mummers (1974), Musical Society (1984), Choral Society (1986), Accordion and Fiddle Society (1990), Pro Musica (1994), and Probus (1997). (See Cycling Club, Knaresborough Players, Scouts and Guides, Silver Band)

SOUTHEIL, URSULA
(See Mother Shipton)

SPA, KNARESBOROUGH
In the seventeenth century, the town was known to physicians and health-seekers as 'the Knaresborough Spa', because it was a popular base for 'taking the waters' long before Harrogate had developed. This is shown by various publications, especially by Dr Deane's *Spadacrene Anglica* (1626) (q.v.), which recommends those staying in Knaresborough to visit not only mineral springs such as the Tewit Well (the first to be discovered, in about 1571, by William Slingsby and nicknamed a 'spa' after the famous spa town in Belgium) and the Old Sulphur Well, but also those at Starbeck, and the Dropping Well (q.v.) and St Robert's Well (q.v.) and St Mungo's Well at Copgrove. Long after the term 'Knaresborough Spa' had fallen into disuse, it was applied to the renewed development at Starbeck. (See Knaresborough Spa, Long Walk)

SPITALCROFT

The name suggests this is the site of an early hospital, hospice or leper colony, probably connected with the friars of St Robert's Priory, who owned this land.

STATUS HIRING FAIR

A corruption of the term Statutes, originally referring to laws for the engagement of labourers in the reign of Edward III. The 'Status' or 'Stattis' in Knaresborough was the hiring fare, when farm-hands and servants were taken on for a year and a day. Traditionally held on the market day before or after 23 November, the women and girls went to the Town Hall, and the men and boys lined up in High Street. Before the First World War, lads were being offered up to £15 a year, girls and women £20 and men £30, with additional board and lodging.

STEAD, THOMAS

Thomas Stead, JP, was the High Street butcher who, from 1904, was elected chairman of the Knaresborough Urban District Council for thirteen years in succession. (See Urban District Council)

STEVENS BIBLES

These were presented along with the Marshall Suits (q.v.) in memory of the evangelical Christian, Maria Stevens, who died in 1840, and according to her memorial in the parish church, 'laboured with unwearied zeal and love for the spiritual benefit of the people of this place.'

STOCK WELL

Surviving amid the modern development of Park Row, this spring, centuries older than the horse-trough dated 1840, was once a valuable water-supply for the stock or animals of drovers passing through, its purity being safeguarded by a Sheriff's Tourn law of 1561: 'No-one is to wash fish in the Stock Well'. Sharing the same supply as a well higher up in York Place, the well has always been noted for the constant temperature of its water and its regular flow, even in conditions of drought.

STUBBS, BISHOP

Born in a house at the entrance to Berry's Passage in 1825, William Stubbs was educated in Knaresborough at Thomas Cartwright's school, then at Ripon Grammar School, from where he went to Oxford. Here he was Professor of Modern History from 1866 to 1884, becoming a Canon of St Paul's, Bishop of Chester, and, in 1889, Bishop of Oxford.

STUTEVILLE FAMILY

A succession of Lords of Knaresborough, the name sometimes spelt D'Estoteville. William de Stuteville, who had succeeded his brother-in-law, Hugh de Morville as Constable of the Castle in 1177, attempted to drive St Robert from the forest but, according to legend, was terrified by demons into favouring him. In 1205, King John fined Nicholas de Stuteville the unreasonable sum of 10,000 marks for illegal inheritance. As he could not possibly pay, King John took possession of the castle the following year.

SUNDAY SCHOOLS

Started in Gloucester in 1780 by Robert Raikes and a Methodist friend, Sophia Cooke, this important educational movement among poor children spread to Knaresborough so that, by 30 January 1785, according to Hargrove, 'near 500 children were entered in this truly laudable establishment'.

SWORD DANCE

The traditional Knaresborough Sword Dance had died out by the early 1800s, but a reconstruction has been used here on Plough Sunday since 1983 by the Claro Sword and Morris Men, who dedicated a revised version of this to Arnold Kellett in 2002. During the dance the longswords are skilfully and elegantly interlaced, and finally woven into a star-shaped 'lock', which is held up by the Squire, the leader of the dancers, a symbol of the sun rising higher and higher in the sky after the winter solstice. (See Plough Sunday)

TELEPHONE

Knaresborough's first public telephone was in operation just before the First World War and run by the National Telephone Service. It was situated in Park Square (top of High Street), at the entrance to which was a board displaying a large bell. In charge was an attendant, one of the first being Mr G. Mann. Soon

there were private numbers, some seen in photographs of local businesses – e.g.
Taylor and Sons, poultry dealers whose horse-and-cart advertised: 'Telephone
17x', and C. E. Smith's Taxis 'No. 4'.

TELLIN' T'TALE
The recital of a potted history of Knaresborough learnt by heart and called out
by children on Low Bridge to visitors and day-trippers in pre-First World War
days, ending with the plea 'Please spare a copper, sir' (or 'lady').

TENTER LODGE
This attractive red-brick house on Waterside was built in 1780 by William
Ibbetson, who took over the nearby Dye-house (q.v.). For an explanation of
the name, see below.

TENTERGATE
An area associated with weavers, mainly of linen in Knaresborough, the cloth
being stretched out to dry on tenter frames (c.f. 'to be on tenterhooks', from old
French *tendre*, to stretch). Originally, this was part of the separate township of
Scriven-with-Tentergate. (See Scriven)

THEATRE
Stage productions in the early years were given at the Town Hall, the Oddfellows
Hall, and various church halls. More recently, they have been at King James's
School and the Frazer Theatre (q.v.).

THISTLE HILL MISSION CHAPEL
Situated at Calcutt, just below Thistle Hill, St Luke's Mission was an off-
shoot of Holy Trinity Church, opened in 1883, largely through donations, in
particular from Miss Margaret Collins.

TOFFEE PARK
(See Mackintosh, Sir Harold)

TOWN COUNCIL

As a result of the Local Government Act of 1972, the Knaresborough Town Council came into being in 1974 as a successor Parish Council. No longer with the authority and independence of the Knaresborough Urban District Council, it is restricted to acting more or less in an advisory capacity to Harrogate Borough Council, which has the final say, particularly in planning matters. It continues to meet, like the KUDC before it, in Knaresborough House on alternate Monday evenings. Though it has lost most of the officers of the KUDC, it has its own Town Clerk and the enhanced status of a Town Mayor, elected each year by the fifteen councillors. The first to be elected mayor was Councillor W. Ronald Mather, who in 1977 became the first Knaresborough person to be elected Mayor of the Harrogate District. (See Knaresborough House, Mayors of Knaresborough, Urban District Council)

TOWN CRIER

The Bellman or Town Crier was for centuries a key figure in the community, especially in days of low literacy. Payment 'to the bellman, for crying' in Knaresborough is recorded as early as 1685. A long-serving Bellman, appointed in 1830, was Thomas Thorpe, also the town's single postman, followed by his son, Christopher. After a lapse the office was revived in 1907, when, at a competition in the Castle Grounds, William Mawson was appointed and given a new bell. In 1988, it was revived again by the Chamber of Trade, who appointed the colourful and enthusiastic Sid Bradley as Town Crier. Sid died in 2009, aged ninety-five. When he retired in 1997 he was followed by the first woman to do the job, Nancy Buckle, whose family had been associated the House in the Rock (q.v.) since the eighteenth century.

TOWN HALL

(See Old Town Hall)

TOWN HALL CAFÉ

Popular venue as restaurant and ballroom, started in the Old Town Hall in 1920 by John William Spencer, later managed by his son, Harold. It was a Knaresborough institution for almost seventy years, especially known to coach parties and for holding wedding receptions, dinners and dances.

TOWN MISSION

During the early 1900s the Town Mission, based on the Primitive Methodist Chapel, Briggate, held services at 3 p.m. and 7 p.m. on Sundays, and did valuable social work during the week. (See Methodists)

TOWN TWINNING

Knaresborough was twinned with the German town of Bebra, near Kassel, during a civic visit there in June 1969. The ceremony involved the Town Clerk, George Barnett, and two enthusiasts, Councillor Albert Holch and the Bürgermeister of Bebra, Herr August-Wilhelm Mende. There was a visit to Knaresborough by a German party the following year, and ever since there have been regular exchanges, especially at grass-roots level, with strong links between, for example, King James's School and the Brüder-Grimm Schule, between the town bands, football teams, and many individuals who have formed life-long friendships. (See Holch, Albert)

'TROMPE L'OEIL' TOWN WINDOWS PROJECT

(See Renaissance Knaresborough)

TUDOR ARCHITECTURE

Apart from the Parish Church the town is not rich in Tudor architecture, but a number of houses conceal it under a later exterior, such as the Tudor Café (now a shop) in the Market Place, and several in High Street. A few, however, are substantially Tudor, dating from at least 1500. (See Dower House, Manor Cottage, Old Manor House, St John's House)

TUG OF WAR

Traditional Boxing Day event at Low Bridge, consisting of a tug of war across the river by teams from the Half Moon and Mother Shipton's, always drawing large crowds. It was started by a challenge from the Half Moon team, led by Bill Jones, in 1968.

TURNBULL, LT D. G.

This pilot in the Royal Flying Corps was killed on 15 April 1917, when delivering a newly manufactured plane from Coventry to Ripon. He broke his

journey in Knaresborough, somewhat disorientated because of heavy showers. He landed in a field on Crag Top, showed local boys his map, then asked them to help him to turn the plane round. When he took off he caught a tree on the edge of the crag, and crashed into the Nidd near Chaffey Dam. There is a memorial plaque in the Parish Church. (See First World War)

UNDERGROUND PASSAGES

Tunnels were certainly excavated from within the castle, providing the garrison with a means of attack or escape during a siege. Two of these are the northern and southern sally-ports, the latter open to the public since 1990. Other tunnels may have reached from the castle further into the town, and one is known to have extended 140 feet from near Fysche Hall in the direction of the castle.

UNITED REFORMED CHURCH

This has a continuous history on the same site since 1697, when the non-conformist Independents, too poor to build a chapel, used an old barn on Windsor Lane belonging to John Wright. This was on land owned by Lady Sarah Hewley of Haya Park (q.v.), a staunch Independent. She gave financial help and a cottage on Windsor Lane for the first minister, the Revd William Benson. By 1716 there was a congregation of sixty, but support dwindled and the Barn chapel closed. Following the visits of John Wesley there was a revival and a re-opening in 1764. The first purpose-built chapel replaced the barn in 1779, the money having been raised by Mrs Thornton, the wife of a London merchant, staying here to take the Harrogate waters. She also provided a new minister, the Revd William Howell (q.v.), who served here from 1778 until 1835, longer even than the vicar, the Revd Thomas Collins (1735–1788). The new Knaresborough Congregationalist church, facing Gracious Street, opened on 3 October 1865, at a cost of £2,200 in Decorated Gothic style, with an elegant 90-foot spire. Among many activities here, the Congregationalists were especially known for their successful Boys Brigade, which, after several decades, finished in about 1998. The name United Reformed church dates from 1972, when the Congregationalists combined with the Presbyterians.

URBAN DISTRICT COUNCIL

A successor to the Improvement Commissioners, who had administered Knaresborough since 1823, the Knaresborough Urban District Council first assembled in the Town Hall (Market Place) on 31 December 1894. The

chairman of the Urban District Council had much more power than the later Town Mayor, and the councillors, divided into committees, administered the town through the various officers and their staff.

VAUX, WILLIAM DE

Appointed Constable of Knaresborough Castle in 1307 by Edward II, he oversaw the complete rebuilding by master mason Hugh of Titchmarsh and his hundred workmen. William de Vaux, with many of the Knaresborough men he led, was killed at the Battle of Bannockburn (1314). (See Castle)

VIADUCT, RAILWAY

One of the most dramatic incidents in the history of Knaresborough was the collapse of the first railway viaduct across the Nidd just after midday, at 12.15 p.m., on Saturday, 11 March 1848. The thunderous roar of falling masonry is said to have lasted five minutes. The foundation stone had been laid amid great rejoicing the previous April by Joseph Dent of Ribston Hall, High Sheriff of Yorkshire. But poor workmanship, shoddy materials and heavy rain led to it crashing into the river when it was almost completed. Tom Collins, later MP for Knaresborough, narrowly missed being crushed, but there was no loss of life, except for multitudes of fish, killed by the lime in the mortar. Waterside was flooded to a depth of 12 feet, and much damage was done, but eventually the viaduct was rebuilt to a design by Thomas Grainger at the joint expense of two railway companies and a cost of £9,803. The contractors Duckett and Stead finally completed this spectacular structure, 90 feet high, 338 feet long, with four arches of 56-foot spans – and it was opened on 1 October 1851. Nicklaus Pevsner deplored the way the railway cut through the heart of the town, but J. B. Priestley admired the way the viaduct, reflected in the river, 'added a double beauty to the scene'. An attractive riverside terrace adjacent to the viaduct was opened in 2009.

VICTORIA, QUEEN

The town's link with the Queen is mainly through her giving patronage to Walton's, manufacturers of Knaresborough linen, who, from 1838, supplied all the royal palaces. There are photographs as well as documentary evidence to show how enthusiastically Knaresborough celebrated the Queen's Golden Jubilee in 1887, and the Diamond Jubilee in 1897. (See Castle Mill, Jubilee, Jubilee Fountain, Walton & Co.)

VIKINGS

Whereas the Norsemen tended to settle in the Dales, the Danish Vikings, following their capture of York, AD 867, and setting up of the Ridings, settled in the flatter Plain of York and the Knaresborough area. This can be seen in street names such as Kirkgate and Briggate, in traditions such as the Knaresborough Sword Dance (q.v.) and the extinct custom of Hoketide, when men removed women's shoes on Easter Sunday, only to have their own hats taken off by the women the following day. (See Knaresborough Cross)

WALKER, ALBERT

A draftsman of remarkable skill who had a particular interest in drawing the old buildings of Knaresborough, many of which have since been demolished (e.g. Wintringham Hall). Working mainly in the 1940s, he produced vivid views with pin-point accuracy.

WALTON & CO.

Linen manufacturers and a major source of employment in Knaresborough for a century and a half, founded in 1785, and managed by John Walton of Byard's Lodge. By 1838 Walton's was employing 272 men, 106 women, 25 boys and 20 girls, the children being educated at Walton's own school. The same year Walton's was appointed suppliers of royal linen by Queen Victoria, with the distinction of being able to weave into their towels names like 'Sandringham' and 'Balmoral'. In 1851, when the firm was well established in Castle Mill, Walton's excelled at the Great Exhibition, quality thereafter being maintained, in spite of fluctuations in trade, until the last linen was woven here in 1972. (See Castle Mill, Linen Industry, Seamless Shirt, Wilson, Harriet)

WAR MEMORIAL

One of the most ideally-situated in the country, Knaresborough's War Memorial stands at the edge of the Castle Grounds, appropriately with military associations, yet enjoying peaceful views of the town and the sound of the river below. Old postcards show the elegant top of the memorial (erected in 1921) which, in this exposed position, was first blown down in the 1930s, then replaced by a stubbier cross following a damaging gale in 1956. For many years a good crowd has assembled here each Remembrance Sunday to honour, in particular, the 156 killed in the First World War and the 55 killed in the Second. 'Greater love hath no man than this, that a man lay down

his life for his friends.' [John 15:13] (See British Legion, First World War, Second World War)

WATER BAG BANK

The lower end of Kirkgate, where it descends to the Nidd, the only fully cobbled street in the town. Its name arises from the fact that leather bags of water were for centuries carried up here from the river, usually slung across the backs of donkeys and horses. In addition, women – just like Jack and Jill – carried pails of water up the hill, at a half-penny a time. This was, however, not Knaresborough's only source of water. (See Water Supply)

WATER CARNIVAL

It is not known when the first Water Carnival was held, but it was at its heyday in late Victorian and Edwardian mid-summers when great crowds filled the seats, specially constructed by Kitching's, below the castle, with a perfect view of Sturdy's boat-landing and the river. An idea of the spectacular entertainment is given by surviving coloured postcards and programmes. For example, there

Water Bag Bank.

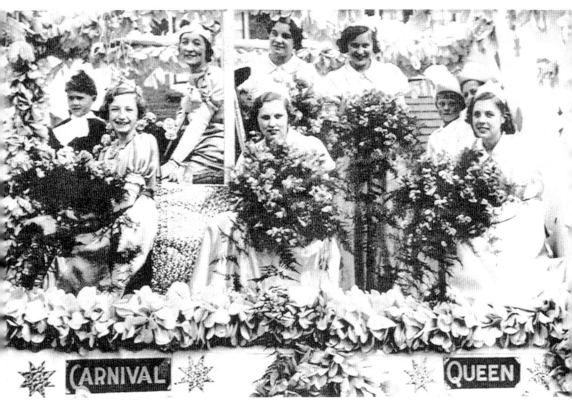

Carnival Queen and retinue at a 1930s Water Carnival.

was the houseboat *Marigold* in mid-stream with a band playing on its upper deck, a procession of flower-bedecked boats led by the 'Fairy Queen of the Carnival', with more music, including mandolin bands, pierrots and glee choirs on floating platforms of punts or boats tied together, and the backcloth of a fairy palace and dancers on the far bank in the Dropping Well estate. Best remembered was the daring tightrope stunt of Don Pedro, pushing a man across the Nidd Gorge in a wheelbarrow, and the Water Carnival at night, with illuminated boats, myriads of coloured fairy-lights set up by George Smith, and especially the firework display by Brocks, with fire raining down from the Viaduct to simulate Niagara Falls.

There was a Water Carnival in 1913, with huge crowds and receipts of £560, but with the First World War the tradition lapsed, until it was revived after the Second World War and held throughout the 1950s, including a riverside bathing-beauty competition. The crowning of a carnival queen survived in the later Children's Day (q.v.).

WATER SUPPLY

The water carried up Water Bag Bank supplemented that which was being drawn from wells in various parts of Knaresborough. As the Nidd was such an abundant and reliable source, however, an Act of Parliament in 1764 authorised Leonard Atkinson and John Lomas to construct a water-wheel by the weir and pump water up into the town. By 1785, leaden pipes had replaced the leaky wooden ones, but it was not until 1871 that the Improvement Commissioners installed a steam engine to supplement the water-wheel. In 1903, they came to an agreement with Harrogate Corporation, and clean water was henceforth supplied from their reservoirs. Even so, poorer homes still had to fetch their water from the nearest tap in the street. (See Cholera, Sanitation, Stock Well, Water Bag Bank)

WATERLOO CHAPEL

Nickname given to the first Methodist chapel, built just off Gracious Street, in 1815, during the difficult year of the Battle of Waterloo. (See Methodists, Sabbath and Day School)

WESLEY, JOHN

The famous evangelist, who covered some 250,000 miles on horseback, visited Knaresborough five times, preaching on texts such as 'By grace are ye saved, through faith'. He came here twice in 1742, then the following year, when the sermon in a crowded house was interrupted by a drunken man who had to be removed. When he came in 1761, though the Methodists had a meeting-house in Castlegate, the crowds were so big he preached in the assembly-room in what is now Whiteley's Yard. Then it was called Savage Yard, and Wesley wrote in his journal: 'Most of the people looked wild enough when they came in, but were tame before they went out.' (See Methodists)

WHEATER, WILLIAM

Author of *Knaresburgh and its Rulers* (1907), based on original documents, in particular the court rolls kept by the official stewards, Powell, Son and Eddison. Though this book contains many useful transcriptions, local historians have found Wheater's assumptions and speculations not always warranted, and his style often stilted and difficult.

WILSON, HARRIET

An outstanding example of loyal service in the linen trade, Miss Harriet Wilson retired in 1935, aged seventy-five, after sixty-two years as a weft-winder with Walton's at Castle Mill. Her father and grandfather had each served here for forty-eight years, her sister for thirty-three years, and her brother for twenty-five years. (See Castle Mill, Linen Manufacture, Walton & Co.)

WINTRINGHAM HALL

Inexcusably demolished in the 1950s, this building at the top of High Street, originally Tudor, was one of Knaresborough's finest old houses, by this time well-known as a hotel and restaurant. Rebuilt in the eighteenth century, it had been the home of Joan Wintringham and Sir William Plumpton, who had secretly married her in 1451. (See Plumpton family)

WITCHCRAFT

The font-cover is evidence of belief in witches, once locked into place to prevent holy water from being stolen (see Parish Church). An example of such theft is the case of a Knaresborough schoolmaster, John Steward, who in 1510 was arrested and accused by an ecclesiastical court in York of stealing holy water and using it to baptise a cockerel, cat and other creatures and of conspiring to seek buried treasure by means of witchcraft. No other individuals in Knaresborough are recorded as suspected witches, and Mother Shipton, in spite of Wolsey's threat to have her burnt, and later fiction by Richard Head, has nearly always been presented as a prophetess, rather than a conventional witch. The Oldest Chemist's Shop sold quills of quicksilver (mercury) to be carried on the person to ward off evil spirits, but this was in the 1700s, and such superstitions have, in general, long since disappeared.

WOODD, BASIL THOMAS

A barrister who settled at Conyngham Hall in 1856, Basil Woodd, JP, was an important public figure in Knaresborough during the second half of the nineteenth century. He was elected Conservative MP for Knaresborough on five occasions – 1852, 1857, 1859, 1865 and 1874. In 1887, he was chairman of the Jubilee Committee and the Burial Board among other offices and, in 1894, was elected the first chairman of the new Urban District Council. The inscription on the organ case in the parish church, given in memory of Basil Woodd in 1897, speaks of his 'bright example of a life well spent in the

service of Church and State'. (See Conyngham Hall, Parliamentary Elections, Town Council)

WOOLLY-HEADED BOY
A rare coloured print of this boy shows him in about 1795 as having a phenomenal head of blond hair, like a fleece. Based on his home, the House in the Rock, the Woolly-Headed Boy gave popular guided tours to historical sites along the river.

WORKHOUSE
The first Knaresborough Workhouse was a three-storey building in front of the parish church, opened in 1737 to accommodate about forty paupers. They were looked after by a Master, who was paid £26 15s a year 'to take care of the Poor finding them Meat, Drink and Fire. Having the Benefit of Work done by the Paupers'. In 1793, the Master, William Borrow, complained of the popularity of the Workhouse in his report to his superiors: 'Gentlemen, I think they come from all parts of the world to Knaresborough, for they know where they get much made on. Pox take 'em all!' Conditions, though, were harsh, and food poor – porridge, broth, suet pudding, and little meat. Some improvement occurred when a new Workhouse was opened in Stockwell Road in 1858.

A report from the early years of the next century shows that 'The County Poor Law Institution, Knaresborough' had a total of 310 residents – '59 infirm men, 36 infirm women, 47 sick males, 66 sick females, 8 maternity cases, 17 children under three, 75 in the casual wards.' This shows that the Workhouse – locally known as 't' Grubber' – was well on the way to becoming a hospital, and was used as such during the First World War. Later adapted as a geriatric unit, Knaresborough Hospital seemed to have a future, and externally its 1858 architecture was attractive, having been designed in mock Tudor style by Isaac Shutt, architect of the Harrogate Royal Pump Room. However, in spite of protests, Harrogate Borough Council authorised its demolition in 1996. (See Hospitals)

WORKING MEN'S CLUB
Originating in the Soldiers' and Sailors' Club, started during the First World War, this moved to its premises in Kirkgate in 1925. It made the news in 1998 when the Duke of Edinburgh paid a visit, and in 2004 when its stewards, Alex and John Dyer, won almost £6 million in the National Lottery, immediately offering to pay for the refurbishment of the Club.

WORLD'S END

This pub on High Bridge dates from around 1898, when it replaced the original tavern. It was owned by Charles Blenkhorn, who also had the boats, hotel and cafe mentioned above and was postmaster; his sister was postmistress.

YORK PLACE

This has some fine Georgian architecture and, according to Nicklaus Pevsner, 'contains the stateliest houses in Knaresborough'.

YORKSHIRE BLUES

Name of the Knaresborough militia raised by Captain William Thornton in 1745 to fight Bonnie Prince Charlie and the Jacobite rebels. Captain Thornton, who lived at Thornville, Cattal Magna, was a Justice of the Peace and later MP for York. He invited John Metcalf, 'Blind Jack', to help him find volunteers, and appointed him assistant to the recruiting sergeant. They went round the district and soon had enlisted 140 men, from which Thornton selected sixty-four, whom he trained and provided with a smart uniform of blue, trimmed with buff, and gold lace, hence the name. With Blind Jack as their musician (he played the oboe as well as the violin), the Yorkshire Blues marched up to Scotland, engaging the enemy at the Battle of Falkirk. Defeated by the Jacobites, some were taken prisoner, but Captain Thornton and Blind Jack managed to escape, and with the rest of the Blues joined the Duke of Cumberland's army in 1746 in the victory and massacre of Culloden. The inhabitants of Knaresborough were so grateful to William Thornton for his patriotic enterprise that they presented him with a silver table inscribed with a tribute in Latin. (See Blind Jack)

ZISLER'S

Pork butcher's shop at the corner of the Market Place and Kirkgate. It was run from 1894 by Mrs Harriet Zisler – an early example of the tradition, brought here from Germany, of making and selling fine-quality pork products. Zisler's advertised, for example, home-cured bacon and ham, polony, pies and sausages 'fresh every day'. The tradition continued in the same shop when George Holch and Son took over after the First World War, and later Smith and Robinson's, then Robinson's. (See Holch, George Albert)

ZOO

Knaresborough Zoo was established in the grounds of Conyngham Hall in 1965 under Nick Nyoka, who made expeditions to the world's jungles to bring back exotic animals. These included Simba, at the time the biggest lion in captivity. The zoo became a popular tourist attraction, especially when Nyoka demonstrated snake-handling. (Nyoka is Swahili for 'snake'.) Irma the elephant was something of a film star and shared her home with breeding bears, lions, tigers, llamas, wallabies, penguins and monkeys. In its heyday, the zoo attracted 150,000 visitors each year, 10,000 of these in school parties. However, by 1985 conditions were not considered satisfactory by Harrogate Borough Council, who refused to renew the licence. A campaign to close the zoo was supported by a visit from Virginia McKenna; others pleaded for its retention, but there was no financial backing, and after an unsuccessful appeal, it closed in November 1986. Nick Nyoka died in 1995. Much of the zoo's land was replaced by Henshaw's Art and Craft Centre in 1999.

Knaresborough History Dateline

10,000 BC (?)	Nidd Gorge formed following Great Ice Age
500 BC	Ancient Britons (Brigantes) give a Celtic name to the River Nidd
AD 74	Romans finally defeat Brigantes, build Isurium Brigantum
410	Angles build the fortified settlement of Knarresburg
705	Synod of Nidd, recorded by St Bede
867	First Vikings settle here, following their capture of York
1066	Norman settlement. Serlo de Burgh, first Lord of Knaresborough
1070	Harrying of the North – brutal Norman suppression. Castle started
1086	Domesday Book. 'Chenaresburgh' with villages, land for twenty-four ploughs
1114	Knaresborough parish church granted by Henry I to Nostell Priory
1133	Eustace Fitz-John sends bread to starving monks building Fountains
1167	Forest of Knaresborough established as a royal hunting-ground
1170	Becket's four murderers, led by Hugh de Moreville, flee to castle
1206	First visit by King John. First reference to Knaresborough Market
1210	First known Royal Maundy: King John gives alms to thirteen paupers
1216	King John visits St Robert in his riverside hermitage, grants him land

1257	Priory of St Robert. Charter from John's son, Richard Plantagenet
1300	Edward I, staying at castle, visits St Robert's tomb
1310	Knaresborough granted its first known Charter by Edward II
1312	Castle rebuilt for Piers Gaveston (twelve towers and a keep)
1314	Edward II orders Knaresborough men to march to Bannockburn
1317	Castle taken by rebel knight John de Lilleburn
1318	Castle recaptured. Scots raid town, burn church and 140 houses
1328	Edward III and Queen Philippa, newly married, in Knaresborough
1331	Queen Philippa granted the Honour of Knaresborough by Edward III
1343	Parish church restored and re-consecrated under Queen Philippa
1349	The Black Death (bubonic plague) reaches Knaresborough
1372	John of Gaunt, Duke of Lancaster, made Lord of Knaresborough
1399	Richard II prisoner in Knaresborough Castle before murder at Pontefract
1408	Chapel of Our Lady of the Crag excavated by John the Mason
1488	Birth of Mother Shipton, according to legend
1451	Sir William Plumpton secretly marries Joan Wintringham
1461	Battle of Towton in War of the Roses. Many Knaresborough men killed
1520	Miniature 'candle-snuffer' spire added to church
1536	Pilgrimage of Grace. Protests against Henry VIII's reforms
1540	Leland, Henry VIII's antiquary, praises castle, market, Dropping Well
1553	Knaresborough returns its first two Members of Parliament
1561	Parish Register started. Protestant service firmly established
1588	Guy Fawkes moves to Scotton. Converted to Catholicism
1600	Death of Francis Slingsby. Tomb in Slingsby chapel
1605	Gunpowder Plot: Guy Fawkes fails to destroy King James
1616	King James's Grammar School founded by Revd Dr Robert Chaloner
1626	Dr Edmund Deane's *Spadacrene Anglica* promotes Knaresborough

1638	Charity for giving bread to the poor – first of many
1641	First account of Mother Shipton's prediction of Wolsey's downfall
1642	Sir Henry Slingsby secures castle for Charles I
1644	Battle of Marston Moor. Siege of Knaresborough Castle
1648	Castle systematically demolished. Cromwell stays in Knaresborough
1658	Sir Harry Slingsby beheaded on Tower Hill. Buried in parish church
1660	Restoration of Charles II
1666	George Fox visits Scotton and Knaresborough
1688	Sir Henry Goodricke proclaims Prince of Orange as King William III
1697	Independents' Barn chapel opens. Celia Fiennes in Knaresborough
1717	Daniel Defoe stays in Knaresborough. Birth of Blind Jack
1720	The Oldest Chemist's Shop in England opens in the Market Place
1732	Blind Jack appointed fiddler for spa visitors at Harrogate inns
1734	Eugene Aram starts school in White Horse Yard, High Street
1735	Revd Thomas Collins, Vicar of Knaresborough (till 1788)
1737	Knaresborough's first Workhouse built near Parish Church
1739	Sir Henry Slingsby lays out the Long Walk to the Dropping Well
1741	King James's Grammar School rebuilt on same site
1742	First visits by John Wesley – Methodist meetings
1744	Linen industry flourishing. Disappearance of Daniel Clark
1745	Yorkshire Blues formed here, march to fight rebels in Scotland
1759	Eugene Aram hanged in York for the murder of Daniel Clark
1764	Act of Parliament authorises a water-pump on the Nidd
1765	Thomas Richardson's Charity School opens. Blind Jack building roads
1768	Knaresborough House, High Street, built for the Collins family
1770	House in the Rock started by a poor linen weaver, Thomas Hill
1774	First known fire-engine. Peal of eight bells in parish church
1785	Walton's linen manufacturers established. Sunday Schools start
1795	First known public library in Knaresborough
1791	Castle Mill built for cotton (later adapted for Walton's linen)

1796	Conyngham Hall built on site of Tudor Coghill House
1803	Free Dispensary of Medicine started by Dr Peter Murray, Castle Ings
1810	Death of Blind Jack at Spofforth, where he is buried
1814	Castle Boys School opens as Church of England National School
1815	Methodist chapel opens off Gracious Street. Cricket Club founded
1818	Death of Ely Hargrove, local historian, aged seventy-seven
1822	Revival of Knaresborough Spa at Starbeck
1823	Act of Parliament authorises Improvement Commissioners to run town
1824	Gas works constructed by John Malam. First street lamps
1825	Birth of William Stubbs, later medieval historian, Bishop of Oxford
1831	St Mary's Catholic church built at Bond End
1837	Castle Girls School opens opposite Castle Boys School
1838	Queen Victoria appoints Walton's suppliers of all royal linen
1843	Literary and Scientific Institution established
1848	Collapse into Nidd of almost-completed railway viaduct
1849	Second outbreak of cholera: thirty-eight deaths. Dinsdale's grocer's established
1851	Viaduct rebuilt. Railway line to Starbeck opens
1853	New Free-Dispensary built in Castle Yard in memory of Revd A. Cheap
1854	Opening of the Primitive Methodist chapel, off Briggate
1856	Holy Trinity church completed, with 166-foot spire
1857	First issue of *Knaresborough Household Almanack*
1858	New Workhouse Stockwell Road, later Knaresborough Hospital
1862	Town Hall built on site of Borough Courthouse
1863	*Knaresborough Post* first published
1865	Congregationalist chapel built, Windsor Lane. Castle Yard Riots
1867	Reform Bill reduces Knaresborough's two MPs to one
1868	New Wesleyan Methodist chapel, Gracious Street
1869	Sir Charles Slingsby drowned in the Ure in a hunting accident
1872	Restoration of parish church of St John's. Oddfellows Hall opened
1876	Knaresborough Cemetery opened

1885	Knaresborough loses right to elect an MP
1887	Queen Victoria's Golden Jubilee. Knaresborough's 'Rejoicings'
1894	Knaresborough Urban District Council. First chairman Basil T. Woodd
1895	Richardson's School amalgamates with King James's Grammar School
1898	Kitching's timber merchants established in Knaresborough
1900	Blenkhorn's New Century Dining Rooms, High Bridge
1901	Grammar School moves to York Road, opened by Lord Harewood
1903	Sellars leather factory burnt down. Chamber of Trade founded
1904	Opening of Park Grove Methodist church
1907	Cattle market at last moves from High Street
1910	12 May, crowded Market Place to hear Proclamation of George V
1911	Population of Knaresborough still only 5,315 (Harrogate 33,703)
1913	Public electric lighting introduced
1914	Outbreak of First World War: hundreds of men volunteer
1915	Council School moves from Gracious Street to Stockwell Road
1916	Slingsby estate broken up and sold by public auction
1918	End of war. Knaresborough has lost 156 men killed in action
1922	A. S. (Sam) Robinson appointed Head of King James's Grammar School
1924	Sir Harold Mackintosh tenant of Conyngham Hall (till 1942)
1926	Public tennis courts opened in castle grounds
1929	Fysche Hall playing fields opened by Lady Evelyn Collins
1931	Moat Gardens (later Bebra Gardens) opened near castle
1939	Outbreak of Second World War. Evacuees, blackout, rationing
1942	Warship Week: Knaresborough greatest savings per head in country
1945	End of war. Knaresborough has lost fifty-four killed
1946	Conyngham Hall and grounds bought by Urban District Council
1947	Philip Inman of Charing Cross Hospital, Lord Inman of Knaresborough
1950	Water Carnival revived. Population of Knaresborough 8,590

1951	KUDC buys Knaresborough House for Council Offices
1953	Celebration of Coronation. New Market Cross dedicated
1960	Friendship and Leisure Centre opened in Market Place
1962	Knaresborough Players founded, later move to Frazer Theatre
1965	Knaresborough Zoo opens. (Closed in 1986)
1966	First Bed Race. 350th Anniversary of King James's Grammar School
1968	First Boxing Day Tug of War: Half Moon *v.* Mother Shipton's
1969	Town Twinning. Albert Holch chairman of Council for sixth time
1971	King James's School starts as 11–18 Comprehensive on same site
1972	Duchess of Kent officially opens King James's School. Pageant
1973	Churchyard of St John's cleared and landscaped
1974	Knaresborough Town Council replaces KUDC First Town Mayor
1975	Methodist church rebuilt in Gracious Street
1977	Courthouse Museum opened. Queen drives through Knaresborough
1983	First Fun Run held by King James's School
1984	Collins Court opened by Lady Elizabeth Collins
1985	Arnold Kellett establishes first known Royal Maundy
1986	Hewitson Court opened in memory of Councillor P. W. Hewitson
1988	Town Crier (Sid Bradley) appointed. First Edwardian Christmas Fair
1989	Knaresborough Community church starts
1990	Opening, after long campaign, of Knaresborough Swimming Pool
1993	Chamber of Trade's first Spring Fair
1996	First Knaresborough Festival of poetry, arts and music (later feva)
1998	Duke of Edinburgh shown Knaresborough, including views of castle
1999	Henshaw's Arts and Crafts Centre opens
2000	New millennium opens: church bells, fireworks, Millennium Pageant
2001	George A. Moore and Arnold Kellett made Freemen of Knaresborough
2002	Market Place re-ordered and partly pedestrianised

2003	King James's wins both Teacher of the Year (Paul Keogh) and Mastermind (Andy Page, former pupil)
2004	Lottery win of just under £6 million by John and Alex Dyer, stewards of Knaresborough Working Men's Club. Age Concern receives Queen's Award for Voluntary Service.
2005	Friends of Bebra Gardens founded
2006	Knaresborough Castle mosaic by Julie Cope
2007	Civic Society's various historical plaques
2008	Miss Jacob-Smith Park opened
2009	Blind Jack Statue by Barbara Asquith installed in Market Place. Viaduct Terrace opened
2010	800th Anniversary of Knaresborough Royal Maundy celebrated here
2011	46th Annual Great Knaresborough Bed Race

Publications on Knaresborough
by Arnold Kellett

The following provide additional details, including illustrations in those marked with one asterisk, coloured where marked with two.

The Knaresborough Story * (1972, new edition 1990)
The Gracious Street Story (1975)
The Queen's Church * (1978)
Knaresborough in Old Picture Postcards * (1984, new edition 1996)
Exploring Knaresborough * (1985)
Scotton and its Methodist Chapel (1985)
King John in Knaresborough: the first known Royal Maundy (*Yorkshire Archaeological Journal* offprint 1990)
Companion to St John's (1990)
Historic Knaresborough ** (1991)
Knaresborough: Archive Photographs * (1995, new edition 2003)
Mother Shipton: Witch and Prophetess * (2002)
King James's School, Knaresborough: 1616–2003 ** (2003)
A-Z Knaresborough History * (2004, revised 2011)
Blind Jack of Knaresborough (2008)
Official Harrogate Borough Council Walkabout folder (First published 1975, later revised 2000)
Articles for the *Knaresborough Post* since 1956, especially *Knaresborough Soundings,* * a series of 46 articles (1988-89) and *Old-Time Knaresborough,* * a series of 53 articles (1998–99)
Knaresborough Millennium Pageant Video (2000) 2 hours of historical reconstruction

Publications by
Paul Chrystal

A Children's History of Harrogate & Knaresborough **, 2011

York Past & Present **, 2010

Paul Chrystal and Mark Sunderland are authors of the following titles in the Amberley Publishing *Through Time* ** series published in 2010: *Knaresborough; North York Moors; Tadcaster; Villages Around York; Richmond & Swaledale; Northallerton.*

Paul Chrystal and Simon Crossley are authors of the following titles in the series to be published in 2011: *Harrogate; Hartlepool; Redcar, Marske & Saltburn; The Vales of Mowbray and York; York: Industries & Business; York: Places of Learning & Worship; Towns and Villages Around York; Pocklington and Surrounding Villages; Around Knaresborough.*

A to Z of Knaresborough History * (2004, revised 2011)

Chocolate: A History of the Chocolate Industry in Britain, 2011 **

A History of Chocolate in York, 2011 **

A to Z of York History (2012)

The Rowntree Family and York (2012)

ALSO AVAILABLE FROM AMBERLEY PUBLISHING

PAUL CHRYSTAL & MARK SUNDERLAND

KNARESBOROUGH

THROUGH TIME

KNARESBOROUGH THROUGH TIME

PAUL CHRYSTAL & MARK SUNDERLAND

This fascinating selection of photographs traces some of the many ways in which Knaresborough has changed and developed over the last century.

ISBN 978 1 84868 854 4
96 pages, full colour throughout